WESTMAR COLLEGE LIBRARY

W9-APW-945

THE SHAPE OF TIME

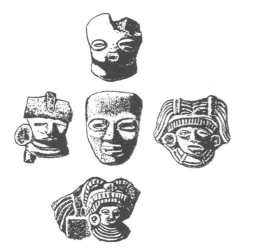

GEORGE KUBLER

THE SHAPE OF TIME

REMARKS ON THE HISTORY OF THINGS

NEW HAVEN AND LONDON: YALE UNIVERSITY PRESS

701.17
K95

N
66
.K8

The title-page and chapter-head illustrations
show pottery figurine fragments made in the
Valley of Mexico between 300 B.C. and about
A.D. 900. All are from Teotihuacán and its
vicinity. (Courtesy American Museum of Natural
History.)

Copyright © 1962 by Yale University
First printing, February 1962
Second printing, March 1963
Set in Aldine Bembo type and
printed in the United States of America by
The Carl Purington Rollins Printing-Office of
the Yale University Press, New Haven, Connecticut.
All rights reserved. This book may not be
reproduced, in whole or in part, in any form
(except by reviewers for the public press),
without written permission from the publishers.

Library of Congress catalog number: 62–8250

Published with assistance from the foundation
established in memory of Rutherford Trowbridge.

59721

TO MARTIN HEINEMANN

Preamble

SYMBOL, FORM, AND DURATION

Cassirer's partial definition of art as symbolic language has dominated art studies in our century. A new history of culture anchored upon the work of art as a symbolic expression thus came into being. By these means art has been made to connect with the rest of history.

But the price has been high, for while studies of meaning received all our attention, another definition of art, as a system of formal relations, thereby suffered neglect. This other definition matters more than meaning. In the same sense speech matters more than writing, because speech precedes writing, and because writing is but a special case of speech.

The other definition of art as form remains unfashionable, although every thinking person will accept it as a truism that no meaning can be conveyed without form. Every meaning requires a support, or a vehicle, or a holder. These are the bearers of meaning, and without them no meaning would cross from me to you, or from you to me, or indeed from any part of nature to any other part.

The forms of communication are easily separable from any meaningful transmission. In linguistics the forms are speech sounds (phonemes) and grammatical units (morphemes). In music they are notes and intervals; in architecture and sculpture they are solids and voids; in painting they are tones and areas.

The structural forms can be sensed independently of meaning. We know from linguistics in particular that the structural ele-

ments undergo more or less regular evolutions in time without relation to meaning, as when certain phonetic shifts in the history of cognate languages can be explained only by a hypothesis of regular change. Thus phoneme *a*, occurring in an early stage of a language, becomes phoneme *b* at a later stage, independently of meaning, and only under the rules governing the phonetic structure of the language. The regularity of these changes is such that the phonemic changes can even be used to measure durations between recorded but undated examples of speech.

Similar regularities probably govern the formal infrastructure of every art. Whenever symbolic clusters appear, however, we see interferences that may disrupt the regular evolution of the formal system. An interference from visual images is present in almost all art. Even architecture, which is commonly thought to lack figural intention, is guided from one utterance to the next by the images of the admired buildings of the past, both far and near in time.

The purpose of these pages is to draw attention to some of the morphological problems of duration in series and sequence. These problems arise independently of meaning and image. They are problems that have gone unworked for more than forty years, since the time when students turned away from "mere formalism" to the historical reconstruction of symbolic complexes.

The main framework of these ideas was set down at Gaylord Farm in Wallingford during November and December in 1959. I am grateful to my family and friends, and to the staff at Gaylord, and to my associates at Yale University, for their many thoughtful attentions to the demands of a restless patient. I wrote most of the text early in 1960 in Naples, and the finished manuscript was submitted to Yale University Press in November of that year. For their perceptive readings and valuable suggestions on its improvement I am indebted to my colleagues at Yale, Professors Charles Seymour, Jr., George H. Hamilton, Sumner McK. Crosby, G. E. Hutchinson, Margaret Collier, George Hersey,

and to Professor James Ackerman of Harvard, whom I taught twenty years ago at Yale. For aid toward publication I am grateful to the Mature Scholars Fund of Yale University.

<div align="right">G. K.</div>

New Haven
15 May 1961

Contents

 # 1. The History of Things

Let us suppose that the idea of art can be expanded to embrace the whole range of man-made things, including all tools and writing in addition to the useless, beautiful, and poetic things of the world. By this view the universe of man-made things simply coincides with the history of art. It then becomes an urgent requirement to devise better ways of considering everything men have made. This we may achieve sooner by proceeding from art rather than from use, for if we depart from use alone, all useless things are overlooked, but if we take the desirableness of things as our point of departure, then useful objects are properly seen as things we value more or less dearly.

In effect, the only tokens of history continually available to our senses are the desirable things made by men. Of course, to say that man-made things are desirable is redundant, because man's native inertia is overcome only by desire, and nothing gets made unless it is desirable.

Such things mark the passage of time with far greater accuracy than we know, and they fill time with shapes of a limited variety. Like crustaceans we depend for survival upon an outer skeleton, upon a shell of historic cities and houses filled with things belonging to definable portions of the past. Our ways of describing this visible past are still most awkward. The systematic study of things is less than five hundred years old, beginning with the description of works of art in the artists' biographies of the Italian Renaissance. The method was extended to the description of all kinds of things only after 1750. Today archaeology and ethnology treat of material culture in general. The history of art treats of the least useful and most expressive products of human

industry. The family of things begins to look like a smaller family than people once thought.

The oldest surviving things made by men are stone tools. A continuous series runs from them to the things of today. The series has branched many times, and it has often run out into dead ends. Whole sequences of course ceased when families of artisans died out or when civilizations collapsed, but the stream of things never was completely stilled. Everything made now is either a replica or a variant of something made a little time ago and so on back without break to the first morning of human time. This continuous connection in time must contain lesser divisions.

The narrative historian always has the privilege of deciding that continuity cuts better into certain lengths than into others. He never is required to defend his cut, because history cuts anywhere with equal ease, and a good story can begin anywhere the teller chooses.

For others who aim beyond narration the question is to find cleavages in history where a cut will separate different types of happening.[1] Many have thought that to make the inventory would lead toward such an enlarged understanding. The archae-

1. I owe my first concern with the problems set forth here to the works and person of the late A. L. Kroeber. Our correspondence began in 1938 soon after I read his remarkable study (with A. H. Gayton) on the Nazca pottery of southern coastal Peru, "The Uhle Pottery Collections from Nasca," *University of California Publications in American Archaeology and Ethnology, 24* (1927). It is a statistical analysis based upon the assumption that undated items belonging to the same form-class can be arranged in correct chronological order by shape-design correlations on the postulate that in one form-class simple formulations are replaced by complex ones. See also A. L. Kroeber, "Toward Definition of the Nazca Style," ibid., *43* (1956), and my review in *American Antiquity, 22* (1957), 319–20. Professor Kroeber's later volume entitled *Configurations of Culture Growth* (Berkeley, 1944) explored more general historic patterns, especially the clustered bursts of achievement marking the history of all civilizations. These themes continued as Kroeber's principal interest in the book of lectures entitled *Style and Civilizations* (Ithaca, 1956).

In an arresting review G. E. Hutchinson, the biologist, compared Kroeber's *Configurations* to internal or free oscillations in animal populations by subjecting Kroeber's work to mathematical expressions like those used in population studies.

ologists and anthropologists classify things by their uses, having first separated material and mental culture, or things and ideas. The historians of art, who separate useful and aesthetic products, classify these latter by types, by schools, and by styles.

Schools and styles are the products of the long stock-taking of the nineteenth-century historians of art. This stock-taking, however, cannot go on endlessly; in theory it comes to an end with irreproachable and irrefutable lists and tables.

In practice certain words, when they are abused by too common use, suffer in their meaning as if with cancer or inflation. Style is one of these. Its innumerable shades of meaning seem to span all experience. At one extreme is the sense defined by Henri Focillon, of style as the *ligne des hauteurs,* the Himalayan range composed of the greatest monuments of all time, the touchstone and standard of artistic value. At the other extreme is the commercial jungle of advertising copy, where gasolines and toilet papers have "style," and another zone where annual fashions in clothes are purveyed as "styles." In between lies the familiar terrain of "historic" styles: cultures, nations, dynasties, reigns, regions, periods, crafts, persons, and objects all have styles. An unsystematic naming on binomial principles (Middle Minoan style, *style François Ier*) allows an illusion of classed order.

The review is reprinted in *The Itinerant Ivory Tower* (New Haven, 1953), pp. 74–77, from which I quote: "The great man, born to the period where dN/dt is maximal [where N is the degree of pattern saturation] can do much. His precursors have provided the initial technical inspiration; much still remains to be done. If he were born to the tradition later he would, with the same native ability, appear less remarkable, for there is less to do. Earlier the work would have been harder; he would perhaps be highly esteemed by a small body of highly educated critics, but would never attain the same popular following as if he had worked at the time of maximum growth of the tradition. The rising and falling that we see in retrospect is thus to be regarded as a movement to and from a maximum in a derived curve. The integral curve giving the total amount of material produced seems to depend little on individual achievement, being additive, and therefore is less easily appreciated. We are less likely to think of 1616 as the date by which most Elizabethan drama has been written than as the date of Shakespeare's death."

But the whole arrangement is unstable: the key word has different meanings even in our limited binomial context, signifying at times the common denominator among a group of objects, and at others the impress of an individual ruler or artist. In the first of these senses style is chronologically unrestricted: the common denominator may appear at widely separated places and times, leading to "Gothic Mannerist" and "Hellenistic Baroque." In the second sense style is restricted in time but not in content. Since the lifetime of one artist often embraces many "styles," the individual and "style" are by no means coterminous entities. The "style Louis XVI" embraces the decades before 1789, but the term fails to specify the variety and the transformations of artistic practice under that monarch's rule.

The immense literature of art is rooted in the labyrinthine network of the notion of style: its ambiguities and its inconsistencies mirror aesthetic activity as a whole. Style describes a specific figure in space better than a type of existence in time.[2]

In the twentieth century, under the impulse of the symbolic interpretation of experience, another direction of study has taken form. It is the study of iconographical types as symbolic expressions of historical change, appearing under a revived seventeenth-century rubric as "iconology." More recently still, the historians of science have conjoined ideas and things in an inquest upon the conditions of discovery. Their method is to reconstruct the heuristic moments of the history of science, and thus to describe happening at its point of inception.

The moment of discovery and its successive transformations as traditional behavior are recovered as a matter of program by the history of science and by iconological studies. But these steps only outline the beginnings and the main articulations of historical substance. Many other possible topics crowd upon the attention

2. Meyer Schapiro, "Style," *Anthropology Today* (Chicago, 1953), pp. 287–312, reviews the principal current theories about style, concluding dispiritedly that "A theory of style adequate to the psychological and historical problems has still to be created."

as soon as we admit the idea that this substance possesses a structure of which the divisions are not merely the inventions of the narrator.

Although inanimate things remain our most tangible evidence that the old human past really existed, the conventional metaphors used to describe this visible past are mainly biological. We speak without hesitation of the "birth of an art," of the "life of a style," and the "death of a school," of "flowering," "maturity," and "fading" when we describe the powers of an artist. The customary mode of arranging the evidence is biographical, as if the single biographical unit were the true unit of study. The assembled biographies then are grouped regionally (e.g. "Umbrian School") or by style and place ("Roman Baroque"), in a manner vaguely patterned upon biological classifications by typology, morphology, and distribution.

The Limitations of Biography

The lives of the artists have been a *genre* in the literature of art ever since Filippo Villani collected anecdotes in 1381–2. Artistic biography was expanded in this century with documents and texts to gigantic proportions as a necessary stage in the preparation of the grand catalogue of persons and works. People writing the history of art as biography assume that the final aims of the historian are to reconstruct the evolution of the person of the artist, to authenticate attributed works, and to discuss their meaning. Bruno Zevi, for instance, praises artistic biography as an indispensable instrument in the training of young artists.[3]

3. A leading figure among younger architectural historians in Italy, Zevi observes in his book-length article on "Architecture" (as published in the American edition of the Italian *Encyclopedia of World Art, 1* [New York, 1959], cols. 683–84) that the recent union between the history of art and studio or drafting-room work, which is now being accomplished in European art education, could not begin until the historians escaped from old misconceptions about art itself, and until historians were ready to "give critical support to the creative experience of

The history of an artistic problem, and the history of the individual artist's resolution of such a problem, thus find a practical justification, which, however, confines the value of the history of art to matters of mere pedagogical utility. In the long view, biographies and catalogues are only way stations where it is easy to overlook the continuous nature of artistic traditions. These traditions cannot be treated properly in biographical segments. Biography is a provisional way of scanning artistic substance, but it does not alone treat the historical question in artists' lives, which is always the question of their relation to what has preceded and to what will follow them.

Individual entrances. The life of an artist is rightly a unit of study in any biographical series. But to make it the main unit of study in the history of art is like discussing the railroads of a country in terms of the experiences of a single traveler on several of them. To describe railroads accurately, we are obliged to disregard persons and states, for the railroads themselves are the elements of continuity, and not the travelers or the functionaries thereon.

The analogy of the track yields a useful formulation in the discussion of artists. Each man's lifework is also a work in a series extending beyond him in either or both directions, depending upon his position in the track he occupies. To the usual coordinates fixing the individual's position—his temperament and his training—there is also the moment of his *entrance,* this being the moment in the tradition—early, middle, or late—with which his biological opportunity coincides. Of course, one person can and does shift traditions, especially in the modern world, in order to find a better entrance. Without a good entrance, he is in danger of wasting his time as a copyist regardless of temperament and training. From this point of view we can see the "universal

contemporary artists." He regards the problem of constructing an artistic education on historical principles as "one of the most vigorous cultural battles of the 1950's" in Europe and America. That battle is still far from over in America. Its continuation appears as foolish now as it was wasteful in the past.

genius" of the Renaissance more simply as a qualified individual
bestriding many new tracks of development at a fortunate mo-
ment in that great renovation of Western civilization, and travel-
ing his distance in several systems without the burdens of rigorous
proof or extensive demonstration required in later periods.

"Good" or "bad" entrances are more than matters of position
in the sequence. They also depend upon the union of tempera-
mental endowments with specific positions. Every position is
keyed, as it were, to the action of a certain range of tempera-
ments. When a specific temperament interlocks with a favorable
position, the fortunate individual can extract from the situation
a wealth of previously unimagined consequences. This achieve-
ment may be denied to other persons, as well as to the same
person at a different time. Thus every birth can be imagined as
set into play on two wheels of fortune, one governing the allot-
ment of its temperament, and the other ruling its entrance into
a sequence.

Talent and genius. By this view, the great differences between
artists are not so much those of talent as of entrance and position
in sequence. Talent is a predisposition: a talented pupil begins
younger; he masters the tradition more quickly; his inventions
come more fluently than those of his untalented fellows. But
undiscovered talents abound as well among people whose school-
ing failed to gear with their abilities, as among people whose
abilities were unrequited in spite of their talent. Predispositions
are probably much more numerous than actual vocations allow
us to suppose. The quality talented people share is a matter of
kind more than degree, because the gradations of talent signify
less than its presence.

It is meaningless to debate whether Leonardo was more
talented than Raphael. Both were talented. Bernardino Luini and
Giulio Romano also were talented. But the followers had bad
luck. They came late when the feast was over through no fault
of their own. The mechanics of fame are such that their prede-
cessors' talent is magnified, and their own is diminished, when

talent itself is only a relatively common predisposition for visual order, without a wide range of differentiation. Times and opportunities differ more than the degree of talent.

Of course many other conditions must reinforce talent: physical energy, durable health, powers of concentration, are a few of the gifts of fortune with which the artist is best endowed. But our conceptions of artistic genius underwent such fantastic transformations in the romantic agony of the nineteenth century that we still today unthinkingly identify "genius" as a congenital disposition and as an inborn difference of kind among men, instead of as a fortuitous keying together of disposition and situation into an exceptionally efficient entity. There is no clear evidence that "genius" is inheritable. Its incidence under nurture, in situations favorable to craft learning, as with adopted children reared in the families of professional musicians, marks "genius" as a phenomenon of learning rather than of genetics.

Purpose has no place in biology, but history has no meaning without it. In that earlier transfer of biological ideas to historical events, of which so many traces survive in the historian's diction, both typology (which is the study of kinds and varieties) and morphology (the study of forms) were misunderstood. Because these modes of biological description cannot be made to account for purpose, the historian working with biological ideas avoided the principal aim of history, which usually has been to identify and reconstruct the particular problem to which any action or thing must correspond as a solution. Sometimes the problem is a rational one, and sometimes it is an artistic one: we always may be sure that every man-made thing arises from a problem as a purposeful solution.

Biological and physical metaphors. However useful it is for pedagogical purposes, the biological metaphor of style as a sequence of life-stages was historically misleading, for it bestowed upon the flux of events the shapes and the behavior of organisms. By the metaphor of the life-cycle a style behaves like a plant. Its first leaves are small and tentatively shaped; the leaves of its

middle life are fully formed; and the last leaves it puts forth are small again but intricately shaped. All are sustained by one unchanging principle of organization common to all members of that species, with variants of race occurring in different environments. By the biological metaphor of art and history, style is the species, and historical styles are its taxonomic varieties. As an approximation, nevertheless, this metaphor recognized the recurrence of certain kinds of events, and it offered at least a provisional explanation of them, instead of treating each event as an unprecedented, never-to-be-repeated *unicum*.

The biological model was not the most appropriate one for a history of things. Perhaps a system of metaphors drawn from physical science would have clothed the situation of art more adequately than the prevailing biological metaphors: especially if we are dealing in art with the transmission of some kind of energy; with impulses, generating centers, and relay points; with increments and losses in transit; with resistances and transformers in the circuit. In short, the language of electrodynamics might have suited us better than the language of botany; and Michael Faraday might have been a better mentor than Linnaeus for the study of material culture.

Our choice of the "history of things" is more than a euphemism to replace the bristling ugliness of "material culture." This term is used by anthropologists to distinguish ideas, or "mental culture," from artifacts. But the "history of things" is intended to reunite ideas and objects under the rubric of visual forms: the term includes both artifacts and works of art, both replicas and unique examples, both tools and expressions—in short all materials worked by human hands under the guidance of connected ideas developed in temporal sequence. From all these things a shape in time emerges. A visible portrait of the collective identity, whether tribe, class, or nation, comes into being. This self-image reflected in things is a guide and a point of reference to the group for the future, and it eventually becomes the portrait given to posterity.

Although both the history of art and the history of science have the same recent origins in the eighteenth-century learning of the European Enlightenment, our inherited habit of separating art from science goes back to the ancient division between liberal and mechanical arts. The separation has had most regrettable consequences. A principal one is our long reluctance to view the processes common to both art and science in the same historical perspective.

Scientists and artists. Today it is often remarked that two painters who belong to different schools not only have nothing to learn from each other but are incapable of any generous communication with one another about their work. The same thing is said to be true of chemists or biologists with different specialties. If such a measure of reciprocal occlusion prevails between members of the same profession, how shall we conceive of communication between a painter and a physicist? Of course very little occurs. The value of any rapprochement between the history of art and the history of science is to display the common traits of invention, change, and obsolescence that the material works of artists and scientists both share in time. The most obvious examples in the history of energy, such as steam, electricity, and internal combustion engines, point to rhythms of production and desuetude with which students of the history of art also are familiar. Science and art both deal with needs satisfied by the mind and the hands in the manufacture of things. Tools and instruments, symbols and expressions all correspond to needs, and all must pass through design into matter.

Early experimental science had intimate connections with the studios and workshops of the Renaissance, although artists then aspired to equal status with the princes and prelates whose tastes they shaped. Today it is again apparent that the artist is an artisan, that he belongs to a distinct human grouping as *homo faber,* whose calling is to evoke a perpetual renewal of form in matter, and that scientists and artists are more like one another as artisans than they are like anyone else. For our purposes of dis-

cussing the nature of happening in the world of things, the differences between science and art are nevertheless irreducible, quite as much so as the differences between reason and feeling, between necessity and freedom. Although a common gradient connects use and beauty, the two are irreducibly different: no tool can be fully explained as a work of art, nor vice versa. A tool is always intrinsically simple, however elaborate its mechanisms may be, but a work of art, which is a complex of many stages and levels of crisscrossed intentions, is always intrinsically complicated, however simple its effect may seem.

A recent phenomenon in Europe and America, perhaps not antedating 1950, is the approaching exhaustion of the possibility of new discoveries of major types in the history of art. Each generation since Winckelmann was able to mark out its own preserve in the history of art. Today there are no such restricted preserves left. First it was classic art that commanded all admiration at the expense of other expressions. The romantic generation again elevated Gothic art to the pedestal. Some *fin de siècle* architects and decorators reinstated Roman Imperial art. Others generated the languors and the botanical elaborations of *art nouveau* on the one hand, or the rebels among them turned to primitivism and archaic art. By a kind of rule of the alternation of generations between tutelary styles of civilized and rude aspect, the next generation adverted to baroque and rococo—the generation that was decimated by the First World War. The revival of interest in sixteenth-century Mannerism which flared during the 1930's not only coincided with great social disorders but it indicated a historical resonance between the men of the Reformation and those of a time of depression and demagogy.[4] After that, nothing was left to discover unless it was contemporary

4. Writing in 1935 (" 'Stilgeschichte' und 'Sprachgeschichte' der bildenden Kunst," *Sitzungsberichte der bayrischen Akademie der Wissenschaften, 31*), Julius von Schlosser referred with feeling to the modern Mannerism being propagated by the "Kopisten, Nachahmer, Industriellen . . . von unserem heutigen Dekadententum."

art. The last cupboards and closets of the history of art have now been turned out and catalogued by government ministries of Education and Tourism.

Seen in this perspective of approaching completion, the annals of the craft of the history of art, though brief, contain recurrent situations. At one extreme the practitioners feel oppressed by the fullness of the record. At the other extreme we have works of rhapsodical expression like those dissected by Plato in the Socratic dialogue with Ion. When Ion, the vain rhapsodist, parades his boredom with all poets other than Homer, Socrates says, ". . . your auditor is the last link of that chain which I have described as held together by the power of the magnet. You rhapsodists and actors are the middle links, of which the poet is the first."[5]

If the fullness of history is forever indigestible, the beauty of art is ordinarily incommunicable. The rhapsodist can suggest a few clues to the experience of a work of art, if he himself has indeed experienced it. He may hope that these hints will assist the hearer to reproduce his own sensations and mental processes. He can communicate nothing to persons not ready to travel the same path with him, nor can he obey any field of attraction beyond his own direct experience. But historians are not middle links, and their mission lies in another quarter.

THE HISTORIAN'S COMMITMENT

The historian's special contribution is the discovery of the manifold shapes of time. The aim of the historian, regardless of his specialty in erudition, is to portray time. He is committed to the detection and description of the shape of time. He transposes, reduces, composes, and colors a facsimile, like a painter, who in his search for the identity of the subject, must discover a patterned set of properties that will elicit recognition all while conveying a new perception of the subject. He differs from the antiquarian

5. *Ion,* tr. Jowett, *Dialogues of Plato* (New York, 1892), vol. 1.

and the curious searcher much as the composer of new music differs from the concert performer. The historian composes a meaning from a tradition, while the antiquarian only re-creates, performs, or re-enacts an obscure portion of past time in already familiar shapes. Unless he is an annalist or a chronicler the historian communicates a pattern which was invisible to his subjects when they lived it, and unknown to his contemporaries before he detected it.

For the shapes of time, we need a criterion that is not a mere transfer by analogy from biological science. Biological time consists of uninterrupted durations of statistically predictable lengths: each organism exists from birth to death upon an "expected" life-span. Historical time, however, is intermittent and variable. Every action is more intermittent than it is continuous, and the intervals between actions are infinitely variable in duration and content. The end of an action and its beginning are indeterminate. Clusters of actions here and there thin out or thicken sufficiently to allow us with some objectivity to mark beginnings and endings. Events and the intervals between them are the elements of the patterning of historical time. Biological time contains the unbroken events called lives; it also contains social organizations by species and groups of species, but in biology the intervals of time between events are disregarded, while in historical time the web of happening that laces throughout the intervals between existences attracts our interest.

Time, like mind, is not knowable as such. We know time only indirectly by what happens in it: by observing change and permanence; by marking the succession of events among stable settings; and by noting the contrast of varying rates of change. Written documents give us a thin recent record for only a few parts of the world. In the main our knowledge of older times is based upon visual evidence of physical and biological duration. Technological seriations of all sorts and sequences of works of art in every grade of distinction yield a finer time scale overlapping with the written record.

Now that absolute confirmations by tree-rings and earth-clocks are at hand, it is astonishing in retrospect to discover how very accurate were the older guesses of relative age based upon seriations and their comparisons. The cultural clock preceded all the physical methods. It is nearly as exact, and it is a more searching method of measurement than the new absolute clocks, which often still require confirmation by cultural means, especially when the evidence itself is of mixed sorts.

The cultural clock, however, runs mainly upon ruined fragments of matter recovered from refuse heaps and graveyards, from abandoned cities and buried villages. Only the arts of material nature have survived: of music and dance, of talk and ritual, of all the arts of temporal expression practically nothing is known elsewhere than in the Mediterranean world, save through traditional survivals among remote groups. Hence our working proof of the existence of nearly all older peoples is in the visual order, and it exists in matter and space rather than in time and sound.

We depend for our extended knowledge of the human past mainly upon the visible products of man's industry. Let us suppose a gradient between absolute utility and absolute art: the pure extremes are only in our imagination; human products always incorporate both utility and art in varying mixtures, and no object is conceivable without the admixture of both. Archaeological studies generally extract utility for the sake of information about the civilization: art studies stress qualitative matters for the sake of the intrinsic meaning of the generic human experience.

The divisions of the arts. The seventeenth-century academic separation between fine and useful arts first fell out of fashion nearly a century ago. From about 1880 the conception of "fine art" was called a bourgeois label. After 1900 folk arts, provincial styles, and rustic crafts were thought to deserve equal ranking with court styles and metropolitan schools under the democratic valuation of twentieth-century political thought. By another line of attack, "fine art" was driven out of use about 1920 by the exponents of industrial design, who preached the requirement of

universal good design, and who opposed a double standard of judgment for works of art and for useful objects. Thus an idea of aesthetic unity came to embrace all artifacts, instead of ennobling some at the expense of others.

This egalitarian doctrine of the arts nevertheless erases many important differences of substance. Architecture and packaging tend in the modern schools of design to gravitate together under the rubric of envelopes; sculpture absorbs the design of all sorts of small solids and containers; painting extends to include flat shapes and planes of all sorts, like those of weaving and printing. By this geometric system, all visible art can be classed as envelopes, solids, and planes, regardless of any relation to use, in a classing which ignores the traditional distinction by "fine" and "minor," or "useless" and "useful" arts.

For our purposes two urgent distinctions should be added. In the first place a great difference separates traditional craft education from the work of artistic invention. The former requires only repetitious actions, but the latter depends upon departures from all routine. Craft education is the activity of groups of learners performing identical actions, but artistic invention requires the solitary efforts of individual persons. The distinction is worth retaining because artists working in different crafts cannot communicate with one another in technical matters but only in matters of design. A weaver learns nothing about his loom and threads from study of the potter's wheel and kiln; his education in a craft must be upon the instruments of that craft. Only when he possesses technical control of his instruments can the qualities and effects of design in other crafts stimulate him to new solutions in his own.

The second, related distinction touches the utilitarian and the aesthetic nature of each of the branches of artistic practice. In architecture and the allied crafts, structure pertains to traditional technical training and it is inherently rational and utilitarian, however daringly its devices may be applied to expressive ends. In sculpture and painting likewise, every work has its technical

cookery of formulas and craft practices upon which the expressive and formal combinations are carried. In addition, sculpture and painting convey distinct messages more clearly than architecture. These communications or iconographic themes make the utilitarian and rational substructure of any aesthetic achievement. Thus structure, technique, and iconography all belong to the non-artistic underpinning of the "fine" arts.

The main point is that works of art are not tools, although many tools may share qualities of fine design with works of art. We are in the presence of a work of art only when it has no preponderant instrumental use, and when its technical and rational foundations are not pre-eminent. When the technical organization or the rational order of a thing overwhelms our attention, it is an object of use. On this point Lodoli anticipated the doctrinaire functionalists of our century when he declared in the eighteenth century that only the necessary is beautiful.[6] Kant, however, more correctly said on the same point that the necessary cannot be judged beautiful, but only right or consistent.[7] In short, a work of art is as useless as a tool is useful. Works of art are as unique and irreplaceable as tools are common and expendable.

THE NATURE OF ACTUALITY

"Le passé ne sert qu'à connaître l'actualité. Mais l'actualité m'échappe. *Qu'est-ce que c'est donc que l'actualité?"* For years this question—the final and capital question of his life—obsessed my teacher Henri Focillon, especially during the black days from 1940 to 1943 when he died in New Haven. The question has

6. See Emil Kaufmann, *Architecture in the Age of Reason* (Cambridge, Mass., 1955), pp. 95–100.

7. Paul Menzer, "Kants Ästhetik in ihrer Entwicklung," *Abhandlungen der deutschen Akademie der Wissenschaften zu Berlin, Kl. für Gesellschaftswissenschaften,* Jahrgang 1950 (1952).

been with me ever since, and I am now no closer to the solution of the riddle, unless it be to suggest that the answer is a negation.

Actuality is when the lighthouse is dark between flashes: it is the instant between the ticks of the watch: it is a void interval slipping forever through time: the rupture between past and future: the gap at the poles of the revolving magnetic field, infinitesimally small but ultimately real. It is the interchronic pause when nothing is happening. It is the void between events.

Yet the instant of actuality is all we ever can know directly. The rest of time emerges only in signals relayed to us at this instant by innumerable stages and by unexpected bearers. These signals are like kinetic energy stored until the moment of notice when the mass descends along some portion of its path to the center of the gravitational system. One may ask why these old signals are not actual. The nature of a signal is that its message is neither here nor now, but there and then. If it is a signal it is a past action, no longer embraced by the "now" of present being. The perception of a signal happens "now," but its impulse and its transmission happened "then." In any event, the present instant is the plane upon which the signals of all being are projected. No other plane of duration gathers us up universally into the same instant of becoming.

Our signals from the past are very weak, and our means for recovering their meaning still are most imperfect. Weakest and least clear of all are those signals coming from the initial and terminal moments of any sequence in happening, for we are unsure about our ideas of a coherent portion of time. The beginnings are much hazier than the endings, where at least the catastrophic action of external events can be determined. The segmentation of history is still an arbitrary and conventional matter, governed by no verifiable conception of historical entities and their durations. Now and in the past, most of the time the majority of people live by borrowed ideas and upon traditional accumulations, yet at every moment the fabric is being undone and a new one is woven to replace the old, while from

time to time the whole pattern shakes and quivers, settling into
new shapes and figures. These processes of change are all mys-
terious uncharted regions where the traveler soon loses direction
and stumbles in darkness. The clues to guide us are very few in-
deed: perhaps the jottings and sketches of architects and artists,
put down in the heat of imagining a form, or the manuscript
brouillons of poets and musicians, crisscrossed with erasures and
corrections, are the hazy coast lines of this dark continent of the
"now," where the impress of the future is received by the past.

To other animals who live more by instinct than do humans,
the instant of actuality must seem far less brief. The rule of instinct
is automatic, offering fewer choices than intelligence, with cir-
cuits that close and open unselectively. In this duration choice is
so rarely present that the trajectory from past to future describes
a straight line rather than the infinitely bifurcating system of
human experience. The ruminant or the insect must live time
more as an extended present which endures as long as the in-
dividual life, while for us, the single life contains an infinity of
present instants, each with its innumerable open choices in vo-
lition and in action.

Why should actuality forever escape our grasp? The universe
has a finite velocity which limits not only the spread of its events,
but also the speed of our perceptions. The moment of actuality
slips too fast by the slow, coarse net of our senses. The galaxy
whose light I see now may have ceased to exist millennia ago, and
by the same token men cannot fully sense any event until after
it has happened, until it is history, until it is the dust and ash of
that cosmic storm which we call the present, and which per-
petually rages throughout creation.

In my own present, a thousand concerns of active business lie
unattended while I write these words. The instant admits only
one action while the rest of possibility lies unrealized. Actuality
is the eye of the storm: it is a diamond with an infinitesimal per-
foration through which the ingots and billets of present possibility
are drawn into past events. The emptiness of actuality can be es-

timated by the possibilities that fail to attain realization in any instant: only when they are few can actuality seem full.

Of arts and stars. Knowing the past is as astonishing a performance as knowing the stars. Astronomers look only at old light. There is no other light for them to look at. This old light of dead or distant stars was emitted long ago and it reaches us only in the present. Many historical events, like astronomical bodies, also *occur* long before they *appear,* such as secret treaties; aide-mémoires, or important works of art made for ruling personages. The physical substance of these documents often reaches qualified observers only centuries or millennia after the event. Hence astronomers and historians have this in common: both are concerned with appearances noted in the present but occurring in the past.

The analogies between stars and works of art can profitably be pursued. However fragmentary its condition, any work of art is actually a portion of arrested happening, or an emanation of past time. It is a graph of an activity now stilled, but a graph made visible like an astronomical body, by a light that originated with the activity. When an important work of art has utterly disappeared by demolition and dispersal, we still can detect its perturbations upon other bodies in the field of influence. By the same token works of art resemble gravitational fields in their clustering by "schools." And if we admit that works of art can be arranged in a temporal series as connected expressions, their sequence will resemble an orbit in the fewness, the regularity, and the necessity of the "motions" involved.

Like the astronomer, the historian is engaged upon the portrayal of time. The scales are different: historic time is very short, but the historian and the astronomer both transpose, reduce, compose, and color a facsimile which describes the shape of time. Historical time indeed may occupy a situation near the center of the proportional scale of the possible magnitudes of time, just as man himself is a physical magnitude midway between the sun and the atom at the proportional center of the

solar system, both in grams of mass and in centimeters of diameter.[8]

Both astronomers and historians collect ancient signals into compelling theories about distance and composition. The astronomer's position is the historian's date; his velocity is our sequence; orbits are like durations; perturbations are analogous to causality. The astronomer and the historian both deal with past events perceived in the present. Here the parallels diverge, for the astronomer's future events are physical and recurrent ones, while the historian's are human and unpredictable ones. The foregoing analogies are nevertheless useful in prompting us to look again at the nature of historical evidence, so that we may be sure of our ground when considering various ways of classing it.

Signals. Past events may be regarded as categorical commotions of varying magnitudes of which the occurrence is declared by inbuilt signals analogous to those kinetic energies impounded in masses prevented from falling. These energies undergo various transformations between the original event and the present. The present interpretation of any past event is of course only another stage in the perpetuation of the original impulse. Our particular interest is in the category of substantial events: events of which the signal is carried by matter arranged in a pattern still sensible today. In this category we are interested less in the natural signals of physical and biological science, than in the artifact signals of history, and among artifact signals we are concerned less with documents and instruments than with the least useful of artifacts —works of art.

All substantial signals can be regarded both as transmissions and as initial commotions. For instance, a work of art transmits a kind of behavior by the artist, and it also serves, like a relay, as the point of departure for impulses that often attain extraordinary magnitudes in later transmission. Our lines of communication

8. Harlow Shapley, *Of Stars and Men* (New York, 1958), p. 48.

with the past therefore originated as signals which become commotions emitting further signals in an unbroken alternating sequence of event, signal, recreated event, renewed signal, etc. Celebrated events have undergone the cycle millions of times each instant throughout their history, as when the life of Jesus is commemorated in the unnumbered daily prayers of Christians. To reach us, the original event must undergo the cycle at least once, in the original event, its signal, and our consequent agitation. The irreducible minimum of historical happening thus requires only an event together with its signals and a person capable of reproducing the signals.

Reconstituted initial events extracted from the signals are the principal product of historical research. It is the scholar's task to verify and test all the evidence. He is not concerned primarily with the signals other than as evidences, or with the commotions they produce. The different commotions in turn are the proper territory of psychology and aesthetics. Here we are interested mainly in the signals and their transformations, for it is in this domain that the traditional problems arise which lace together the history of things. For instance, a work of art is not only the residue of an event but it is its own signal, directly moving other makers to repeat or to improve its solution. In visual art, the entire historical series is conveyed by such tangible things, unlike written history, which concerns irretrievable events beyond physical recovery and signaled only indirectly by texts.

Relays. Historical knowledge consists of transmissions in which the sender, the signal, and the receiver all are variable elements affecting the stability of the message. Since the receiver of a signal becomes its sender in the normal course of historical transmission (e.g. the discoverer of a document usually is its editor), we may treat receivers and senders together under the heading of relays. Each relay is the occasion of some deformation in the original signal. Certain details seem insignificant and they are dropped in the relay; others have an importance conferred by their relationship to events occurring in the moment of the relay,

and so they are exaggerated. One relay may wish for reasons of temperament to stress the traditional aspects of the signal; another will emphasize their novelty. Even the historian subjects his evidence to these strains, although he strives to recover the pristine signal.

Each relay willingly or unwittingly deforms the signal according to his own historical position. The relay transmits a composite signal, composed only in part of the message as it was received, and in part of impulses contributed by the relay itself. Historical recall never can be complete nor can it be even entirely correct, because of the successive relays that deform the message. The conditions of transmission nevertheless are not so defective that historical knowledge is impossible. Actual events always excite strong feelings, which the initial message usually records. A series of relays may result in the gradual disappearance of the animus excited by the event. The most hated despot is the live despot: the ancient despot is only a case history. In addition, many objective residues or tools of the historian's activity, such as chronological tables of events, cannot easily be deformed. Other examples are the persistence of certain religious expressions through long periods and under great deforming pressures. The rejuvenation of myths is a case in point: when an ancient version becomes unintelligibly obsolete a new version, recast in contemporary terms, performs the same old explanatory purposes.[9]

The essential condition of historical knowledge is that the event should be within range, that some signal should prove past existence. Ancient time contains vast durations without signals of any kind that we can now receive. Even the events of the past few hours are sparsely documented, when we consider the ratio of events to their documentation. Prior to 3000 B.C. the texture

9. H. Hubert and M. Mauss, "La Représentation du temps dans la religion," *Mélanges d'histoire des religions* (Paris, Alcan, 2nd ed., 1929), pp. 189–229. On mythopoetic transformations of historical personages, see for example V. Burch, *Myth and Constantine the Great* (Oxford, 1927).

of transmitted duration disintegrates more and more the farther we go back. Though finite, the total number of historical signals greatly exceeds the capacity of any individual or group to interpret all the signals in all their meaning. A principal aim of the historian therefore is to condense the multiplicity and the redundancy of his signals by using various schemes of classification that will spare us the tedium of reliving the sequence in all its instantaneous confusion.

Of course, the writing of history has many extremely practical uses, each of which imposes upon the historian a viewing range suited to the purpose in hand. For example, the judges and counsel in a law court may expend upon the determination of the sequence of events leading to a murder, an amount of effort vastly greater than the events themselves required for their happening. At the other extreme, when I wish to mention Columbus' first voyage to America, I do not need to collect all the signals, such as documents, archaeological indications, earthclock measurements, etc., to prove the date 1492: I can refer to credible secondary signals derived from firsthand sources. In between these extremes, an archaeologist tracing a buried floor level with his assistants spends about the same energy upon reading the signal as the original builders put into the floor in the first instance.

Hence a primary signal—meaning the evidence closest to the event itself—may require a great expense of energy for its detection and interpretation, but once the signal has been brought in it can be repeated at a fraction of the cost of the original detection. In this way the fundamental determinations of history relate to detecting and receiving primary signals from the past, and they usually concern simple matters of date, place, and agent.

For the most part the craft of history is concerned with the elaboration of credible messages upon the simple foundations afforded by primary signals. More complex messages have widely varying degrees of credibility. Some are fantasies existing in the minds of the interpreters alone. Others are rough approxima-

tions to historical truth, such as those reasonable explanations of myths called euhemerist.[10]

Still other complex messages are probably stimulated by special primary signals of which our understanding is incomplete. These arise from extended durations and from the larger units of geography and population; they are complex, dimly perceived signals which have little to do with historical narrative. Only certain new statistical methods come near to their detection, such as the remarkable lexicostatistical discoveries made in glottochronology, the study of the rate of change of languages (pp. 60–61).

SELF-SIGNALS AND ADHERENT SIGNALS

These remarks so far pertain mainly to one class of historical signals, to distinguish them from the more obvious messages of another kind which we have not yet discussed. These other signals, including writing, are added to the self-signal, and they are quite different from it, being adherent rather than autogenous. The self-signal can be paraphrased as the mute existential declaration of things. For example, the hammer upon the workbench signals that its handle is for grasping and that the peen is an extension of the user's fist ready to drive the nail between the fibres of the plank to a firm and durable seat. The adherent signal, die-stamped on the hammer, says only that the design is patented under a protected trade-mark and manufactured at a commercial address.

A fine painting also issues a self-signal. Its colors and their distribution on the plane of the framed canvas signal that by making certain optical concessions the viewer will enjoy the simultaneous experience of real surfaces blended with illusions of deep space occupied by solid shapes. This reciprocal relation of real surface and deep illusion is apparently inexhaustible. Part of the self-signal is that thousands of years of painting still have not

10. Anne Hersman, *Studies in Greek Allegorical Interpretation* (Chicago, 1906).

exhausted the possibilities of such an apparently simple category of sensation. Yet this self-signal is the least honored and the most overlooked of the dense stream of signals issuing from the picture.

In the consideration of painting, architecture, sculpture, and all their allied arts, the adherent signals crowd in upon most persons' attention at the expense of the autogenous ones. In a painting, for example, the dark foreground figures resemble persons and animals; a light is depicted as if emanating from the body of an infant in a ruined shelter; the narrative bond connecting all these shapes must be the Nativity according to St. Luke; and a painted scrap of paper in one corner of the picture bears the name of the painter and the year of the work. All these are adherent signals composing an intricate message in the symbolic order rather than in an existential dimension. Adherent signals of course are essential to our study, but their relations with one another and with the self-signals make up part, and only part of the game, or the scheme, or the problem that confronted the painter, to which the picture is the resolution in actual experience.

The existential value of the work of art, as a declaration about being, cannot be extracted from the adherent signals alone, nor from the self-signals alone. The self-signals taken alone prove only existence; adherent signals taken in isolation prove only the presence of meaning. But existence without meaning seems terrible in the same degree as meaning without existence seems trivial.

Recent movements in artistic practice stress self-signals alone, as in abstract expressionism; conversely, recent art scholarship has stressed adherent signals alone, as in the study of iconography. The result is a reciprocal misunderstanding between historians and artists: the unprepared historian regards progressive contemporary painting as a terrifying and senseless adventure; and the painter regards most art scholarship as a vacant ritual exercise. This type of divergence is as old as art and history. It recurs in every generation, with the artist demanding from the scholar the approval of history for his work before the pattern is com-

plete, and the scholar mistaking his position as an observer and historian for that of a critic, by pronouncing upon matters of contemporary significance when his perceptive skill and his equipment are less suited to that task than to the study of whole past configurations which are no longer in the condition of active change. To be sure, certain historians possess the sensibility and the precision that characterize the best critics, but their number is small, and it is not as historians but as critics that they manifest these qualities.

The most valuable critic of contemporary work is another artist engaged in the same game. Yet few misunderstandings exceed those between two painters engaged upon different kinds of things. Only long after can an observer resolve the differences between such painters, when their games are all out, and fully available for comparison.

Tools and instruments are recognized by the operational character of their self-signal. It is usually a single signal rather than a multiple one, saying that a specific act is to be performed in an indicated way. Works of art are distinguished from tools and instruments by richly clustered adherent meanings. Works of art specify no immediate action or limited use. They are like gateways, where the visitor can enter the space of the painter, or the time of the poet, to experience whatever rich domain the artist has fashioned. But the visitor must come prepared: if he brings a vacant mind or a deficient sensibility, he will see nothing. Adherent meaning is therefore largely a matter of conventional shared experience, which it is the artist's privilege to rearrange and enrich under certain limitations.

Iconographic studies. Iconography is the study of the forms assumed by adherent meaning on three levels, natural, conventional, and intrinsic. Natural meaning concerns primary identifications of things and persons. Conventional meanings occur when actions or allegories are depicted which can be explained by reference to literary sources. Intrinsic meanings constitute the study called iconology, and they pertain to the explanation of

cultural symbols.[11] Iconology is a variety of cultural history, in which the study of works of art is devoted to the extraction of conclusions concerning culture. Because of its dependence upon long-lived literary traditions, iconology so far has been restricted to the study of the Greco-Roman tradition and its survivals. Continuities of theme are its principal substance: the breaks and ruptures of the tradition lie beyond the iconologist's scope, like all the expressions of civilizations without abundant literary documentation.

Configurational analysis. Certain classical archaeologists in turn also have been much concerned with similar questions about meaning, especially in respect to the relations between poetry and visual art. The late Guido v. Kaschnitz-Weinberg and Friedrich Matz[12] are the principal representatives of this group, who engage in the study of meaning by the method of *Struktur-analyse,* or configurational analysis, in an effort to determine the premises underlying the literature and art of the same generation in one place, as for example, in the case of Homeric poetry and the coeval geometric vase painting of the eighth century B.C. Thus *Strukturforschung* presupposes that the poets and artists of one place and time are the joint bearers of a central pattern of sensibility from which their various efforts all flow like radial expressions. This position agrees with the iconologist's, to whom literature and art seem approximately interchangeable. But the archaeologists are more perplexed by the discontinuities between painting and poetry than the iconologists are: they still find it difficult to equate the Homeric epic with Dipylon vases. This perplexity reappears among students of modern art, to whom literature and painting appear sharply divergent in content and technique. Erudition and pornography are exalted and conjoined in present-day literature, but they are both avoided in painting,

11. Erwin Panofsky, *Studies in Iconology* (New York, 1938).

12. Friedrich Matz, *Geschichte der griechischen Kunst* (Frankfurt, 1950), 2 vols. The introduction is an exposition of *Strukturforschung,* for which an English approximation might be "studies of form-field relations."

where the quest for non-representational form has been the principal aim in our century.

The difficulty can be removed by modifying the postulate of a central pattern of sensibility among poets and artists of the same place and time. It is unnecessary to reject the idea of central pattern altogether, because the quest for erudite expression, for instance, was shared by poets and painters alike in seventeenth-century Europe. It is enough to temper the conception of the governing configuration (*Gestalt*) with the conception of the formal sequence set forth here on pp. 33 f. Formal sequences presuppose independent systems of expression that may occasionally converge. Their survival and convergence correspond to a shared purpose which alone defines the field of force. By this view the cross-section of the instant, taken across the full face of the moment in a given place, resembles a mosaic of pieces in different developmental states, and of different ages, rather than a radial design conferring its meaning upon all the pieces.

The taxonomy of meaning. Adherent meanings vary categorically according to the entities they clothe. The messages that can be conveyed in Meissen porcelain differ from those of large bronze sculpture. Architectural messages are unlike those of painting. The discussion of iconography or iconology immediately raises taxonomic questions, analogous to those of distinguishing the fur, feather, hair, and scales of the biological orders: all are integuments, but they differ from one another in function, in structure, and in composition. Meanings undergo transformations by mere transfer, which are mistaken for changes in content.

Another difficulty arising from the treatment of iconography as a homogeneous and uniform entity is the presence of large historical groupings within the body of adherent meaning. These are related more to the mental habits of different periods than to incorporation as architecture, sculpture, or painting. Our historical discriminations still are too imprecise to document these

mental changes generation by generation, but the outlines of large, coarse changes are clearly evident, such as the differences of iconographic system before and after A.D. 1400 in Western civilization.

In the middle ages or during antiquity, all experience found its visual forms in a single metaphorical system. In antiquity the *gesta deorum* enveloped the representation of present happening. The Greeks preferred to discuss contemporary events under a mythological metaphor, like that of the labors of Hercules, or in terms of the epic situations of Homeric poetry. The Roman emperors adopted biographical archetypes among the gods, assuming the names, the attributes, and the cults of the deities. In the middle ages the lives of the saints fulfilled the same function, as when the regional histories of Reims or Amiens found their expression in the statues of local saints standing in the cathedral embrasures. Other variations on the principal narratives of Scripture conveyed further details of local history and sentiment. This preference for reducing all experience to the template set by a few master themes resembles a funnel. It channels experience into a more powerful flow; the themes and patterns are few in number but their intensity of meaning is thereby increased.

About A.D. 1400 many technical discoveries in the pictorial representation of optical space allowed, or more probably, accompanied, the appearance of a different scheme of stating experience. This new scheme was more like a cornucopia than a funnel, and from it tumbled an immense new variety of types and themes, more directly related to daily sensation than the preceding modes of representation. The classical tradition and its reawakening formed only one current in the torrent of new forms embracing all experience. It has been at flood height and steadily rising ever since the fifteenth century.

The survival of antiquity has perhaps commanded the attention of historians mainly because the classical tradition has been superseded; because it is no longer a live water; because we are now

outside it, and not inside it.[13] We are no longer borne by it as in a current upon the sea: it is visible to us from a distance and in perspective only as a major part of the topography of history. By the same token we cannot clearly descry the contours of the great currents of our own time: we are too much inside the streams of contemporary happening to chart their flow and volume. We are confronted with inner and outer historical surfaces (p. 54). Of these only the outer surfaces of the completed past are accessible to historical knowledge.

13. E. Panofsky, *Renaissance and Renascences* (Stockholm, 1960), has commented at some length on the end of the modern age in the present century.

2. The Classing of Things

Only a few art historians have sought to discover valid ways to generalize upon the immense domain of the experience of art. These few have tried to establish principles for architecture, sculpture, and painting upon an intermediate ground partly in the objects and partly in our experience of them, by categorizing the types of organization we perceive in all works of art.

One strategy requires enlarging the unit of historical happening. At the beginning of the century F. Wickhoff and A. Riegl moved in this direction when they replaced the earlier moralizing judgment of "degeneracy" that had been passed upon Late Roman art, with the hypothesis that one system or organization was being replaced by a new and different system of equal value. In Riegl's terms, one "will-to-form" gave way to another.[1] Such a division of history, along the structural lines marked by the frontiers between types of formal organization, has had reserved approval from almost all twentieth-century students of art and archaeology.

These proposals differed altogether from the notions of necessary sequence first advanced by the Swiss historian of art, Heinrich Wölfflin, whose work was classed with the "theory of pure visibility" by Benedetto Croce.[2] Wölfflin compared fifteenth-

1. A. Riegl, *Die Spätrömische Kunstindustrie* (Vienna, 1901–23), 2 vols.

2. The term itself arose according to Croce ("La teoria dell'arte come pura visibilità," *Nuovi saggi di estetica* [Bari, 1926], pp. 233–58) in conversation among Hans von Marées, Conrad Fiedler, and Adolf Hildebrand in Munich. The date was probably about 1875. Wölfflin's most celebrated work is *Kunstgeschichtliche Grundbegriffe* (Munich, 1915).

century and seventeenth-century Italian art. By pointing out five polar opposites in the realization of form (linear-painterly; surface-depth; closed-open; multiplicity-unity; absolute-relative clarity) he usefully characterized some fundamental differences of morphology in the two periods. Other writers soon extended the conception to both Greco-Roman and medieval art, in a three-part division of each by archaic, classic, and baroque stages. A fourth stage called mannerism (the sixteenth century) was inserted about 1930 between classic and baroque. Occasionally writers even have promoted the rococo and neo-classic styles to the dignity of stages in the life-cycle. Wölfflin's categories had great influence in affecting the historical scholarship both of music and literature, without ever reaching unquestioned acceptance among art historians themselves.

There, the archive-minded specialists naturally found new documents more useful than stylistic opinions spun from Wölfflin's *Grundbegriffe,* and at the other extreme, the rigorous historians condemned Wölfflin because he neglected the individual qualities of things and artists in trying to frame general observations concerning their classes. The boldest and most poetic affirmation of a biological conception of the nature of the history of art was Henri Focillon's *Vie des Formes* (1934). The biological metaphor was of course only one among many pedagogical devices used by that marvelous teacher who turned everything to good account in firing the common clay of his hearers. Uninformed critics have misunderstood his extraordinary inventiveness of mind as rhetorical display, while the more ponderous ones have dismissed him as another formalist.

The shapes of time are the prey we want to capture. The time of history is too coarse and brief to be an evenly granular duration such as the physicists suppose for natural time; it is more like a sea occupied by innumerable forms of a finite number of types. A net of another mesh is required, different from any now in use. The notion of style has no more mesh than wrapping paper or storage boxes. Biography cuts and shreds a frozen historic

substance. Conventional histories of architecture, sculpture, paint-
ing, and the cognate crafts miss both the minute and main details
of artistic activity. The monograph upon a single work of art is
like a shaped stone ready for position in a masonry wall, but that
wall itself is built without purpose or plan.

FORMAL SEQUENCES

Every important work of art can be regarded both as a
historical event and as a hard-won solution to some problem. It
is irrelevant now whether the event was original or conventional,
accidental or willed, awkward or skillful. The important clue is
that any solution points to the existence of some problem to
which there have been other solutions, and that other solutions
to this same problem will most likely be invented to follow the
one now in view. As the solutions accumulate, the problem
alters. The chain of solutions nevertheless discloses the problem.

Linked solutions. The problem disclosed by any sequence of
artifacts may be regarded as its mental form, and the linked solu-
tions as its class of being. The entity composed by the problem
and its solutions constitutes a form–class. Historically only those
solutions related to one another by the bonds of tradition and
influence are linked as a sequence.

Linked solutions occupy time in a great variety of ways, dis-
cussed in the remainder of this book. They disclose a finite yet
uncharted domain of mental forms. Most of these are still open
to further elaboration by new solutions. Some are closed, com-
pleted series belonging to the past.

In mathematical usage a series is the indicated sum of a set of
terms, but a sequence is any ordered set of quantities like the
positive integers.[3] A series therefore implies a closed grouping,

3. *Mathematics Dictionary,* ed. Glenn James and R. C. James (Princeton, 1959),
pp. 349–50. Professor Oystein Ore, of Yale University, to whom I showed this
chapter after he told me about the work he is completing on graph theory, wrote
the following assessment: "In attempting to give a systematic presentation of so

and a sequence suggests an open-ended, expanding class. The mathematical distinction is worth keeping in this discussion.

In general, formal sequences exceed the ability of any individual to exhaust their possibilities. An occasional person, born by chance into a favoring time, may contribute beyond the usual measure of a single life-span, but he cannot alone simulate in his life the corporate activity of a whole artistic tradition.

The mathematical analogy for our study is topology, the geometry of relationships without magnitudes or dimensions, having only surfaces and directions. The biological analogy is speciation, where form is manifested by a large number of individuals undergoing genetic changes.

Where are the boundaries of a formal sequence? Because his-

complex a subject matter one would be inclined, as in the natural sciences, to look to the mathematicians for some pattern to serve as a descriptive principle. The mathematical concepts of series and sequences came to mind but after some thought these appear to be too special for the problem at hand. However, the less known field of networks or directed graphs seems to be considerably more suitable.

"We are concerned with the variety of stages in the creativity of the human race. From one stage one moves to another in the development. There are a variety of directions which may be selected. Some represent actual happenings. Others are only possible steps among many available ones. Similarly each stage may have occurred among several possible steps leading to the same result.

"This one may picture in a general way by the mathematical concept of a directed graph or network. Such a graph consists of a number of points or vertices or stages. Some of these are connected by a directed line, an edge or a step. At each stage there is therefore a number of alternative edges which may be followed, and also a number of incoming edges from which this stage could have resulted. The actual development corresponds to a (directed) path in the graph and it is only one among many possible ones.

"One may ask whether the graphs we should like to consider are of a special type among the many directed graphs which can be constructed. There seems to be one essential restriction, that the graphs shall be acyclic, that is, there exists no cyclic directed path returning to its original stage. This essentially corresponds to the observation about human progress that it never returns to the previous conditions."

tory is unfinished business, the boundaries of its divisions continually move, and will continue to move for as long as men make history. T. S. Eliot was perhaps the first to note this relationship when he observed that every major work of art forces upon us a reassessment of all previous works.[4] Thus the advent of Rodin alters the transmitted identity of Michelangelo by enlarging our understanding of sculpture and permitting us a new objective vision of his work.[5]

For our purposes here, the boundaries of a sequence are marked out by the linked solutions describing early and late stages of effort upon a problem. With a sequence having many stages, there was a time when it had fewer. More new ones may be added in the future. The sequence can continue only when the problem is given greater scope by new needs. As the problem expands, both the sequence and its early portions lengthen.

Open and closed sequences. When problems cease to command active attention as deserving of new solutions, the sequence of solutions is stable during the period of inaction. But any past problem is capable of reactivation under new conditions. Aboriginal Australian bark-painting is an open sequence in the twentieth century, because its possibilities are still being expanded by living artists, but Greek vase-painting is an arrested sequence (p. 109) because the modern painter needed to renew his art at "primitive" sources rather than among the images of the Hellenic world. The transparent animals and humans of Australian painting, and the rhythmic figures of African tribal sculpture correspond more closely to contemporary theories of reality than to the opaque and unequivocal body forms of Greek art.

The method imposed by such considerations is analytical and

4. T. S. Eliot, "Tradition and the Individual Talent," *Selected Essays, 1917–32* (New York, 1932), p. 5. Also, *Points of View* (London, 1941), pp. 25–26.

5. André Malraux has appropriated the "Eliot effect" in several passages of *The Voices of Silence* (New York, 1954), pp. 67, 317, 367, where major artists are represented as altering their respective traditions retroactively by their own novel contributions.

divisive rather than synthetic. It discards any idea of regular cyclical happening on the pattern of "necessary" stylistic series by the biological metaphor of archaic, classic, and baroque stages. Sequence classing stresses the internal coherence of events, all while it shows the sporadic, unpredictable, and irregular nature of their occurrence. The field of history contains many circuits which never close. The presence of the conditions for an event does not guarantee the occurrence of that event in a domain where man can contemplate an action without committing it.

Simple biographical narration in the history of art tends to display the entire historical situation in terms of an individual's development. Such biography is a necessary stage of reconstruction, but a formal sequence designates chains of linked events by an analysis which requires us to do the opposite: to perceive the individual in terms of his situation.

Sequence classing allows us to bridge the gap between biography and the history of style with a conception less protean than biological or dialectic theories of the dynamics of style, and more powerfully descriptive than biography. Its dangers and its limitations will be readily apparent. In the long run, the conception of a sequence may serve as a scaffolding which it may be convenient to discard later on, after it has given access to previously invisible portions of the historical edifice.

It is disturbing to those who value the individuality of a thing to have that individuality diminished by classifications and generalizations. We are caught between difficulties: single things are extremely complicated entities, so complicated that we can pretend to understand them only by generalizing about them (p. 96). One way out is frankly to accept the complexity of single things. Once their difficulty is conceded, it is possible to find aspects that can be used in comparisons. No such trait now known is unitary or fundamental: every trait of a thing is both a cluster of subordinate traits as well as a subordinate part of another cluster.

An example from French Gothic cathedral architecture: several

generations of architects struggled to coordinate the regular sequence of the vaulted nave bays with the great weights of the façade towers. These had to rest in part upon nave supports ideally no thicker one than any other. A solution gradually was perfected, by thickening the bearing walls beneath the tower periphery, by augmenting the buttressing, and by sacrificing excessive slenderness in the proportioning of the nave supports.[6]

At Mantes Cathedral the west façade was among the earliest to show this perfected solution by compromise. The architect wanted a uniform rhythm of equivalent supports under evenly distributed light. He wanted a formal value toward which technical solutions could help him. The volume of the interior is uninterrupted, yet the mass of the façade is immense. Both objectives have been brought to a close·fit, however inconsistent they may have seemed in the first place. This solution in Gothic cathedral architecture implicated a cluster of subordinate traits such as columns, buttresses, and windows, whose further alteration was governed by the façade solution. The façade solution was itself subordinate to another system of changes respecting the composition of the towers.

Hence "cathedrals" are not a true form-class but an ecclesiastical category and an administrative conception in canon law. Among the edifices thus designated, there is a handful of closely related designs built in northern Europe between 1140 and 1350. These are part of a sequence of forms that also includes some abbeys and some parish churches. The formal sequence is not "cathedrals." It is more like "segmented structures with rib vaults," and it excludes barrel-vaulted cathedrals.

The closest definition of a formal sequence that we now can venture is to affirm it as a historical network of gradually altered repetitions of the same trait. The sequence might therefore be described as having an armature. In cross section let us say that it shows a network, a mesh, or a cluster of subordinate traits;

6. Hans Kunze, *Das Fassadenproblem der französischen Früh-und Hochgotik* (Leipzig, 1912; dissertation, Strassburg).

and in long section that it has a fiber-like structure of temporal stages, all recognizably similar, yet altering in their mesh from beginning to end.

Two questions immediately arise: in the first place, are formal sequences not indefinitely numerous? No, because each corresponds to a conscious problem requiring the serious attention of many persons for its successful resolution. There are no linked solutions without there having been a corresponding problem. There is no problem where there is no awareness. The contours of human activity as a whole are therefore congruent with those of the totality of formal sequences. Each class of forms consists of a real difficulty and of real solutions. In the course of time, most of these solutions may have been destroyed, but that difficulty is only an apparent one, for our determinations of sequence can if necessary be founded upon only one surviving solution or example. Such determinations are of course provisional and incomplete. Yet every object attests to the existence of a requirement for which it is the solution, even when that object is only a late copy in a long series of coarsened products far removed from the clarity and sharpness of an original.

In the second place, are we going to consider all man-made objects or only a selection of them? Where is the minimal boundary? We are concerned mainly with works of art rather than with tools, and we are interested more in long durations than in brief ones, which tell us less about our subject. Tools and instruments commonly have extremely long durations. Upon occasion these extend so far that it is difficult to note great changes, as, for example, in the minor inflections that record the passage of civilizations in the cooking pots of a deep refuse midden. A working rule is that the simpler tools record very large durations, and that the more complicated tools record brief episodes of special needs and inventions.

Fashions. The minimal boundary perhaps lies near the limits of fashion. Fashions in dress are among our briefest durations. A fashion obeys special demands to which the longer evolutions

are impervious. A fashion is the projection of a single image of outward being, resistant to change during its brief life, ephemeral, expendable, receptive only to copying but not to fundamental variation. Fashions touch the limit of credibility by violating the precedent and by grazing the edge of the ridiculous. They belong not to a connected chain of solutions, but they constitute, each fashion in turn, classes of only one member each. A fashion is a duration without substantial change: an apparition, a flicker, forgotten with the round of the seasons. It is like a class, but it differs from a sequence by having no appreciable dimension in time.

PRIME OBJECTS AND REPLICATIONS

If tools on the one hand, and fashions on the other mark out our provisional boundaries, we need now to set further divisions inside the domain. There are prime objects and replicas as well as the spectator's and the artist's views of the situation of the work of art in time.

Prime objects and replications denote principal inventions, and the entire system of replicas, reproductions, copies, reductions, transfers, and derivations, floating in the wake of an important work of art. The replica-mass resembles certain habits of popular speech, as when a phrase spoken upon the stage or in a film, and repeated in millions of utterances, becomes a part of the language of a generation and finally a dated cliché.

It will be useful first to examine the nature of the prime object from which a replica-mass derives. Prime objects resemble the prime numbers of mathematics because no conclusive rule is known to govern the appearance of either, although such a rule may someday be found. The two phenomena now escape regulation. Prime numbers have no divisors other than themselves and unity; prime objects likewise resist decomposition in being original entities. Their character as primes is not explained by their antecedents, and their order in history is enigmatic.

The annals of art, like those of bravery, directly record only a handful of the many great moments that have occurred. When we consider the class of these great moments, we are usually confronted with dead stars. Even their light has ceased to reach us. We know of their existence only indirectly, by their perturbations, and by the immense detritus of derivative stuff left in their paths. We shall never know the names of the painters of Bonampak, nor those of Ajanta: indeed, the wall paintings at Bonampak and Ajanta, like the Etruscan tomb murals, are probably only pale reflections of a lost art that graced the more urban halls of living princes. The history of art in this sense resembles a broken but much-repaired chain made of string and wire to connect the occasional jeweled links surviving as physical evidences of the invisible original sequence of prime objects.

Mutants. Although biological metaphors are avoided throughout this essay, their occasional use for clarifying a difficult distinction is justified when we are talking about prime objects. A prime object differs from an ordinary object much as the individual bearer of a mutant gene differs from the standard example of that species. The mutant gene may be infinitesimally small but the behavioral differences which it occasions can be very great indeed.

In addition, the idea of a prime object requires a fundamental adjustment in our ideas of the integrity and unity of the work of art. The mutant fraction imposes consequences upon the progeny of the thing. But altogether different is the field of action assumed for the whole object. These differences are of the same order as between an act of procreation and an act of moral example. A possibility for change appears with the mutant-bearing prime object, while a generally beautiful or distasteful object merely calls for ritual repetition or avoidance.

Our interest therefore centers upon minute portions of things rather than upon the whole mosaic of traits that constitutes any object. The effect of the mutant fraction, or prime trait, is dy-

namic in provoking change while that of the whole object is simply exemplary, exciting feelings of approval or dislike more than any active study of new possibilities. *Diagnostic difficulties.* Strictly considered, a form-class exists only as an idea. It is incompletely manifested by prime objects, or things of great generating power, in the category of the Parthenon, or of the portal statues at Reims, or of the frescoes by Raphael in the Vatican. Their physical presence is always dimmed by the accidents of time, but their prime status is unquestionable. It is guaranteed by direct comparisons with other things of lesser quality, and by a variety of testimonials from artists in many generations. Yet the Parthenon is built upon an archaic formula surviving into Periclean time. The portal statues of Reims embrace the work of several generations, and all, including the frescoes by Raphael, have undergone damaging wear and diminution. In the biologists' language, they are all three phenotypes, from which we have to deduce the originating genotypes.

These three examples, however, are extremely special ones illustrating the phenomenon of the climactic *entrance.* Such entrances occur at moments when the combinations and permutations of a game are all in evidence to the artist; at a moment when enough of the game has been played for him to behold its full potential; at a moment before he is constrained by the exhaustion of the possibilities of the game to adopt any of its extreme terminal positions.

Every stage of the game, whether early or late, contains prime objects variously qualified according to their entrances. But the number of surviving prime objects is astonishingly small: it is now gathered in the museums of the world and in a few private collections; and it includes a large proportion of celebrated buildings. It is likely that buildings constitute the majority of our prime objects, being immobile and often indestructible objects. It is also likely that a large proportion of

prime objects was made of perishable substances like cloth and paper, and that another large proportion was made of precious metal and melted down when needed.

The classic example is the gigantic statue of Athena Parthenos made by Phidias in gold and ivory for the Parthenon, known only by mean replicas made for pilgrims and tourists. Another example: many splendors of the fourth-century world under Constantine the Great are known to us only by the terse and gray descriptions of the "Bordeaux pilgrim" who traveled through southern Europe and North Africa in A.D. 333.[7] This unique tourist's chronicle is a part of the replica-mass of the Early Christian world, and its accidental survival has justified the devoted labors of several generations of scholars in establishing its text and annotating its contents. Still another example of the difference between prime objects and replica-masses is the daily crossword puzzle. The manuscript draft by the puzzle-maker is a prime object (which no one conserves); all the solutions in subways and on the desks of people who "kill time" compose the replica-mass.

Since a formal sequence can be deduced only from things, our knowledge of it depends upon prime objects and their replicas. But the number of prime objects is distressingly small, and as most of our evidence consists of copies or other derivative things, these inferior expressions, which often are very far removed from the original impress of the responsible mind, therefore must occupy much of the historian's time.

An important question arises at once. If, in a given sequence an initial prime object begins the connected series, why are the subsequent prime objects of the series not to be regarded as replicas? The question is particularly urgent when we recall that prime objects surely known to arise from prime traits are very few. In many places and periods it is impossible to identify them among the accumulated collections of replicas. The question ex-

7. O. Cuntz, *Itineraria romana* (Leipzig, 1929), vol. 1.

tends in all directions: are we ever in the unmistakable presence of an initial prime object? Can such an entity be isolated? Have prime objects any real existence? Or are we simply conferring upon some leading examples of their class an additional symbolic distinction of imaginary priority? The questions caution us against misplaced concreteness, but they should not weaken the main thesis. Man-made objects of all kinds correspond to human intentions in historical sequence. Prime objects correspond to prime traits, or to mutant intentions, while replicas merely multiply the prime objects. Though its type is extremely traditional, the Parthenon is recognizable as prime by many refinements lacking in other temples of its series. But the copies of the Athena Parthenos statue in the National Museum at Athens, or the Strangford shield in the British Museum, only coarsen and reduce the original without increments of any kind.

Many sorts of replicas reproduce the prime object so completely that the most sensitive historical method cannot separate them. In another kind of seriation, each replica differs slightly from all the preceding ones. These accumulated variations may originate without design, merely for relief from monotonous repetition. In time their drift is perceived and brought to order by an artist, who imposes upon the mass of replicas a new scheme manifested by a prime object not categorically different from the preceding prime object, yet historically different in that it corresponds to a different age of the formal sequence to which the prime objects both belong. Neither of these models of historical happening makes the discovery of prime objects easy: we can maintain only that they must have existed in numbers corresponding to the critical moments of change in all the classes of sequence. They may have existed only as random notes or sketches. Their first full appearances may be indistinguishable in many instances from the immediately subsequent replicas. The shelves of every museum of archaeology are organized to display this conception of the sequence of artifacts. One group of replicas arranged by type adjoins another group on another

shelf. The two masses are alike yet different. They are on good evidence assigned to different periods. They correspond either to different ages of the same sequence or to its different regional varieties.

We shall revert to these questions at more length in the next chapter; here it is important to bring out once more the elusive nature of prime objects. Signatures and dates inscribed upon works of art by their authors in no way assure us that they are prime. Most works of art, moreover, are anonymous, and they fall naturally into large groups. Under most circumstances the prime objects have disappeared into the mass of replicas, where their discovery is most difficult and problematic, akin to the greater difficulty of discovering the first recognizable examples of the biological species. In reality our knowledge of sequences is for the most part based upon replicas.

Our distinction between prime objects and replicas also illustrates a capital difference between European and non-European arts. With European objects we often can approach closer to the hot moment of invention than in non-European ones, where our knowledge is so often based only upon replicas of uniform or debased quality. A long tradition of collecting and connoisseurship appears only among Chinese, Japanese, and European peoples; elsewhere in the world the continual accumulation of things was never systematically ordered by the efforts of collectors and critics, so that the prime objects virtually all have been lost from view.

No formal sequence is ever really closed out by the exhaustion of all its possibilities in a connected series of solutions. The revalidation of old problems in new circumstances is always possible and sometimes actual, like the renewal of stained-glass technique as the *gemmeau* glass newly invented in France since the war.[8] The use of fracture to modulate the light rather than

8. W. Pach, "The Gemmeaux of Jean Crotti: A Pioneer Art Form," *Magazine of Art, 40* (1947), 68–69. The novelty consists in laminating different colors of glass without leading. The glass sandwich then is cracked for graduated scintillation.

leaded fences between color areas, is a case illustrating the manner in which an entire older tradition can become a point of departure when technical novelties require its reactivation. For long intervening periods a formal sequence may nevertheless seem inactive, simply because the technical conditions for its revival are not yet present. Such inactive classes deserve to be ranked in order of apparent completion, that is, by the length of time since any innovation enlarged the class. By this criterion all the classes of form are still open sequences, and it is only by an artificial convention that we may call any class a historically closed series.

Serial appreciation. A pleasure shared by artists, collectors, and historians alike is the discovery that an old and interesting work of art is not unique, but that its type exists in a variety of examples spread early and late in time, as well as high and low upon a scale of quality, in versions which are antetypes and derivatives, originals and copies, transformations and variants. Much of our satisfaction in these circumstances arises from the contemplation of a formal sequence, from an intuitive sense of enlargement and completion in the presence of a shape in time.

As the linked solutions accumulate, the contours of a quest by several persons are disclosed, a quest in search of forms enlarging the domain of aesthetic discourse. That domain concerns affective states of being, and its true boundaries are rarely if ever disclosed by objects or pictures or buildings taken in isolation. The continuum of connected effort makes the single work more pleasurable and more intelligible than in isolation. Rebecca West perceived this rule of appreciation by series when she declared in *The Strange Necessity* that the main justification for much ordinary literature is the stimulation which it provides for critics.[9]

Appreciation of the series nevertheless runs counter to the main drift of modern literary criticism, which has been set since about 1920 against the "intentional fallacy,"[10] or judgment by

9. R. West, *The Strange Necessity* (New York, 1928), esp. "The Long Chain of Criticism."

10. W. K. Wimsatt, Jr. and M. C. Beardsley, "The Intentional Fallacy," *The Sewanee Review*, 54 (1946), 468–88.

setting instead of by intrinsic merit. Here the "new critics" held that the poet's intention does not extenuate his performance, and that all criticism must be within the poem itself regardless of its historical and biographical conditions.

A literary work, however, consists only of verbal meanings: such principles of criticism would fail of application in the visual arts, where verbal symbols are incidental, and where an elementary problem arises. It is a familiar problem in literature, which experts usually have settled before the poem or the play reaches the student. This is the matter of "establishing the text," of compiling and comparing all the versions and variant readings to find the clearest, most consistent sequence. The study of the history of things is actually only at this stage of "establishing the text," of discovering the "scripts" of the principal themes.

An unmistakable erosion wears down the contours of every work of art, both in its physical form, which is gradually obliterated by dirt and wear, and by the disappearance of so many steps in the artist's elaboration of his conceptions. Often he makes no record whatever, and we can only conjecture what the stages of design may have been. If there are diagrams, sketches, and drawings, their number is always small because the artist was more generous than today in the direction of the wastebasket, and he did not hoard the chips and shavings of his day's labors for the art market. In Greek and Roman sculpture, this kind of erosion has eliminated virtually all traces of the individual's processes of elaboration: we usually have only replicas and poor copies to give us an abraded and coarsened conception of remote originals altogether lost to view. "Establishing the text" under these circumstances is a laborious necessity of study, and the editors who perform it deserve more reward than they get. Without it we should have no sequence in time, no measure of the distances between versions, and no conception whatever of the authority and power of the lost originals.

Some themes are trivial; others are excessively factual; but somewhere between triviality and factuality lie the formal se-

quences whose territorial definition we are seeking. A trivial case is the history of buttons: it is trivial because there are few events in the history of the button; there are only variants in shape, size, and decoration; there is no duration in respect to difficulties encountered and overcome. An example of excessive factuality is the textbook on the whole history of world art, which must embrace all the principal events from paleolithic painting to the present. It can set forth only some names and dates, and some general principles for the understanding of works of art in their historical setting. It is a work of reference, and it cannot relate or resolve problematic matters.

Still other historical themes describe convergent happenings rather than linked events: an example is the conventional discussion of paleolithic cave painting together with South African Bushman rock paintings of recent date, made probably after A.D. 1700. There is no demonstrable link between the two groups, however much they may look alike. They are sixteen thousand years apart without connecting historical tissue. Indeed, paleolithic cave painting cannot be shown to connect with anything until its discovery in the nineteenth century. Its own internal history is still vague, lacking detailed articulation by periods and groupings. Both paleolithic and Bushman paintings can profitably be considered, nevertheless, as elements of a formal sequence including contemporary art, together with the efforts of various individuals to assimilate and transform the prehistoric "tradition" which entered the stream of modern consciousness only late in the nineteenth century.

Technical renewals. When trying to understand the composition of formal sequences, we may with profit look briefly into the question of craft techniques. The name of art is itself close to technical cunning. The devices and artifices of planned illusion are the working gear of the artist who is engaged in substituting his own codes of time and space for our older and less interesting ones.

Among craftsmen a technical innovation can often become the

point of departure for a new sequence where all the elements of
the tradition are revised in the light of the possibilities opened to
view by the innovation. An example is the displacement of
black-figured vase painting near the end of the sixth century
B.C. by red-figured technique.[11] This amounted to a reversal of
figure and ground in order to favor the figure and to convert
the ground from a decorative setting into an atmospheric dis-
tance.

 The technical change in the potter's firing habits may of course
have been brought into being by the painter's specific demands
for such a renovation of the conditions of the craft, but the
probability is that the "new" technical habit was available long
before an artist seized upon it for his needs. To this general
topic—of invention in relation to change—we must return later;
here, however, it is useful to show how one sequence may yield
to another when an item in the composition of the original se-
quence is significantly altered. We have chosen a technical ex-
ample in the history of vase-painting; other case histories might
be taken from innovations in the painter's subject matter, or in
expressive attitude, or in perspective convention. The point is
that the formal sequence always corresponds to a distinct con-
ception of potential series of changes.

 Conversely, be it noted that many technological innovations
provoke no immediate development. Heron's aeolipile of the
first century A.D.[12] was an oddity without consequences for
seventeen centuries until the sustaining economic, sociological,
and mechanical conditions for the development of steam en-
gines were at hand. The example points to abortive, retarded,
or stunted sequences of which occurrences can also be identified
in the arts. Henri Focillon used to speak of the "failures that lurk
in the shadow of every success" when he described the oddities
—such as eight-part vaults—strewn along the definitive line of

11. G. M. A. Richter, *Attic Red-Figured Vases* (New Haven, 1946), pp. 46–50.
 12. A. G. Drachmann, *Ktesibios, Philon and Heron. A Study in Ancient Pneumatics*
(Copenhagen, 1948).

four-part rib-vault construction in twelfth-century France.[13] They too are examples of the stunted sequence. The chances of such retarded classes being called into renewed being are unpredictable, although obscure technical failures have sometimes been revived for further development after long periods of oblivion, especially in the history of science.

The linked series of solutions composing a sequence is not necessarily restricted to a single craft. On the contrary, it is more likely to appear when different crafts come into play at the same time. Thus Greek vase painters probably took many suggestions from the pictorial achievements of the wall painters, which in turn (at least in Etruscan tomb painting of Greek style) may have borrowed certain schemes from vase painting, such as processional profile figures.

The formal sequence thus may find its realization in several crafts simultaneously. An example is afforded by the abrupt contrasts of light and shadow in seventeenth-century chiaroscuro composition, allowing novel illusions of depth and movement. This new organization of the surfaces rapidly spread throughout all the visual arts. No province of Europe escaped the dominion of these forms: the contagion spread from city to court, or from court to city, as in Holland, where there were only cities, and from thence to every cranny of the social structure, exempting only the most isolated communities, or those too poor to renew their churches, houses, and pictures.

The invisible chain. An ancient tradition of representation shows us the poet inspired by the muse.[14] His posture with lifted pen betrays the greater presence as he receives the message from another sphere of being. His whole body strains upward and the folds of his clothing flutter upon the breath of the spirit. The best-known versions show the Evangelists receiving the Gospels;

13. H. Focillon, *Art d'Occident* (Paris, 1938), p. 188. S. Quiriace at Provins: "une de ces expériences sans lendemain."

14. A. M. Friend, Jr., "The Portraits of the Evangelists in Greek and Latin Manuscripts," *Art Studies*, 5 (1927), 115–50; 7 (1929), 3–29.

others portray Church fathers or saintly scholars. The posture
of divine inspiration sometimes also appears in the representa-
tions of painters engaged upon sacred images: Saint Luke, who
depicts the Virgin[15] in the altarpiece by Roger van der Weyden,
appears as a Flemish burgher, suffused by the light of the event,
and poised with raised stylus like the Evangelists of Carolingian
illuminations.

Like the Evangelists, like Saint Luke, the artist is not a free
agent obeying only his own will. His situation is rigidly bound
by a chain of prior events. The chain is invisible to him, and it
limits his motion. He is not aware of it as a chain, but only as
vis a tergo, as the force of events behind him. The conditions im-
posed by these prior events require of him either that he follow
obediently in the path of tradition, or that he rebel against the
tradition. In either case, his decision is not a free one: it is dic-
tated by prior events of which he senses only dimly and indi-
rectly the overpowering urgency, and by his own congenital
peculiarities of temperament.

Prior events are more significant than temperament: the his-
tory of art abounds in examples of misplaced temperaments,
like the romantics wrongly born in periods requiring classic
measure, or the innovators living in periods governed by rigid
rule. Prior events exercise a selective action upon the spectrum
of temperaments, and each age has shaped a special temperament
to its own uses both in thought and in action. Among artists,
the prior events that determine the individual's actions constitute
the formal sequences we have been discussing. They are the
events composing the history of the quest that most closely con-
cerns the individual. His position in that quest is a position he
cannot alter, but only realize. The theme of possession by the
work in hand is evident in many artistic biographies: the indi-
vidual is driven in every action by forces of an intensity absent
from other lives; he is possessed by his vision of the possible,

15. D. Klein, *St. Lukas als Maler der Maria* (Berlin, 1933).

and he is obsessed with the urgency of its realization, in a solitary posture of intense effort, traditionally represented by the figures of the poet or the muse. Prior events and future possibilities within the sequence: these dimensions govern the position of every work of art. The notebook of Villard de Honnecourt, the thirteenth-century architect, contains a sketch of one of the towers of Laon Cathedral, and under it he wrote, "Nowhere have I ever seen a tower like this." The itinerant master-builder was not only praising the work of a predecessor; he was also challenging it, as if to say "this good way has been done, and I can improve it."[16]

Such possibilities seem actively to possess the people who explore them. Vasari recorded the obsession of Paolo Uccello with the perspective construction of painted surfaces.[17] Much of Cézanne's work tells us of his long obsession with the ideal landscape through its prior realizations in Romano-Campanian painting and in the art of Poussin, whose canvases Cézanne studied in the Louvre.[18] Every major artist betrays such an obsession: its traces are legible in works by men whose historical identity has otherwise vanished, like the Maya architects and sculptors at Palenque or Uxmal.

Probably the individual is immunized against other unrelated interests by his obsession, in the sense that he does not often make major contributions in more than one formal sequence except under special conditions. Such conditions occur at the end of a series of related forms, when the person privileged to make a terminal statement must then shift his labors to another class of forms. Examples of this kind of shift commonly are disguised in biographical writing as different periods in one man's

16. H. R. Hahnloser, *Villard de Honnecourt* (Vienna, 1935), pl. 19 and pp. 49–50. *"J'ai este en m[u]lt de tieres, si co[m] v[os] pores trover en cest liv[r]e; en aucun liu, onq[ue]s tel tor ne vi co[m] est cell de Loo[n]."*

17. G. Vasari, *Lives*, trans. G. de Vere (London, 1910–12), 2, 131–40: "perspective . . . kept him ever poor and depressed up to his death" [1475].

18. Gertrude Berthold, *Cézanne und die alten Meister* (Stuttgart, 1958).

work, corresponding to old and new circuits of influence. But changes of period also concern sequences in different stages of development, among which the individual is seeking the viable choice, where he can still challenge the past with a notable improvement.

Solitary and gregarious artists. In this game of jockeying for position—and it goes on in every generation—there are further elements of variation afforded by the play of temperaments and endowments. Guercino's change c.1621–23 from baroque to classic form was intended to satisfy his clients, and it displays an interaction between the painter and his surroundings much more than it relates to any major shift of formal substructure, as Denis Mahon has shown in his *Studies in Seicento Art and Theory* (1947).

Some sequences require contributions from many different kinds of sensibility. The presence of pairs of great rivals engaged in contrasting ways upon the same problems at the same time usually defines such situations: Poussin and Rubens, Bernini and Borromini thus marked out the wide roads of seventeenth-century painting and architecture. The contemporary revalidation of primitive experience also has been carried by contrasted pairs, like Eliot and Joyce or Klee and Picasso. Such pairs and groups emerge upon the scene of only the most ample investigations, and not in the narrowing galleries of more restricted interests, where we find Uccello and Cézanne, less as rivals than as isolated prospectors alone with their obsessions.

Each great branch of art calls upon a different temperament. Painting and poetry more than all others invite the solitary nature. Architecture and music summon the gregarious man to whom work in company is a requirement of his nature best satisfied by the division of labor and by concerted entrances. The outstanding innovator among artists, like Caravaggio, nevertheless is functionally lonely. His break with tradition may or may not be known to the multitude, but he is himself of necessity aware of the isolation it brings. The work of the associates and pupils immediately around him derives from his own,

and it is of a thinner quality. His non-professional contemporary admirers are likely to know him in his person more than in his work.

Usually the entire range and bearing of such a career can be brought into focus only long after death, when we can place it in relation to preceding and subsequent events. But by then the shock of the innovation has faded. We may tell ourselves that these pictures or buildings once broke with the tradition. But in our present they have entered the tradition as if by simple chronological distance.

Probably all important artists belong to this functionally lonely class. Only occasionally does the artist appear as a rebel, as in the sixteenth and in the nineteenth centuries. More commonly he has been a courtier, a part of the household of the prince, an entertainer, whose work was valued like that of any other entertainer, and whose function was to amuse more than to disquiet the audience.

Today the artist is neither a rebel nor an entertainer. To be a rebel requires more effort away from his work than the artist wants to make. The entertainers have formed professional guilds in those many categories of public amusement from which the artist is now almost completely excluded. Only the playwright still functions both as an artist and as an entertainer. More lonely than ever, the artist today is like Dedalus, the strange artificer of wonderful and frightening surprises for his immediate circle.

SERIAL POSITION, AGE, AND CHANGE

In mathematical usage (p. 33), series and sequence differ as closed and open classes of events. In the foregoing pages we assumed that most classes are open-ended sequences. Here, however, we will assume that most classes can be treated as closed series. The difference between the two points of view depends upon the viewer's position, whether he wishes to be inside or out-

side the events in question. From the inside, most classes look like open sequences; from outside they seem to be closed series. In order to reconcile both positions, let us say that the conception of the formal sequence outlined in the preceding section allows us to assemble the ideas of things, with their first realizations and with the consequent mass of replicas, as events into connected finite series.

The rule of series. Every succession may be stated in the following propositions: (1) in the course of an irreversible finite series the use of any position reduces the number of remaining positions; (2) each position in a series affords only a limited number of possibilities of action; (3) the choice of an action commits the corresponding position; (4) taking a position both defines and reduces the range of possibilities in the succeeding position.

Stated differently: every new form limits the succeeding innovations in the same series. Every such form is itself one of a finite number of possibilities open in any temporal situation. Hence every innovation reduces the duration of its class. The boundaries of a class are fixed by the presence of a problem requiring linked solutions: classes may be small or large: we are here concerned only with their internal relationships and not with their dimensions or magnitudes.

One more proposition allows us to qualify the mode of duration. Each series, originating in its own class of forms, has its own minimal duration for each position, depending upon the effort required. Small problems require small effort; large ones demand more effort and so consume more time. Any effort to shortcut the circuit leads to failure. The rule of series requires each position to be occupied for its corresponding period before the next position can be taken. In purely technological domains this is self-evident: the steam engine was invented before the locomotive, but the *mise au point* of a locomotive required many more parts, each consuming its portion in the economy of the time sequence, than a steam engine alone. In works of art the

rule of minimal durations is even more rigorous, marked by collective attitudes of acceptance or rejection, which we shall discuss later. These cannot be short-circuited by fortuitous discoveries as in the technological fields. For example, the discovery of a luminous paint was no help to the painter engaged in an attempt to record on canvas the play of light in nature: he was bound to achieve his unconventional aim with conventional materials.

Our procedure is rather to recognize the recurrence of a need in differing stages of its gratification, and the persistence of a problem throughout various efforts to solve it. Every need evokes a problem. The juncture of each need with successive solutions leads to the conception of sequence. It is a conception much narrower yet more labile than that of any biological metaphor, for it considers only human needs and their satisfaction, in a one-to-one correspondence between needs and things, without the intermediary of any other irrelevant entity like "life-cycle." The main difficulty arises in the specification of "needs," but we have carefully sidestepped that question by restricting the discussion to relationships rather than to magnitudes.

Systematic age. We need here to study the nature of durations. To speak of sequences or series, that is, of specified needs and their successive stages of satisfaction, is to mark a variety of durations. No duration, however, can be discussed save in respect to its beginning, middle, and end, or to its early and its late moments. In one duration, we are agreed that "late" cannot precede "early." Hence we may speak of the *systematic age* of each item in a formal series according to its position in the duration.

Easily recognized visual properties mark the systematic age of any item, once we have identified its series. It is not the purpose of this book to dwell upon the techniques and kinds of chronological discrimination, yet certain fundamental observations are indispensable. Early solutions (promorphic) are technically simple, energetically inexpensive, expressively clear. Late solutions (neomorphic) are costly, difficult, intricate, recondite, and

animated. Early solutions are integral in relation to the problem they resolve. Late ones are partial in being addressed more to the details of function or expression than to the totality of the same problem. Our terms, promorphs and neomorphs, have the permission of the best dictionaries, and they avoid the promiscuous contamination of terms such as "primitive" and "decadent," and "archaic" or "baroque." But these determinations depend upon defining the pertinent form-class, for otherwise the visual properties of late solutions in one class may deceptively resemble those of early solutions in another class. Late and early are perforce relative to a defined starting point. They will inevitably remain as parameters until some absolute measure of visual position in time is devised.

For the present, let us begin with the idea of simultaneity. The simultaneous existence of old and new series occurs at every historical moment save the first. At that totally imaginary moment, and only then, were all the efforts of men in the same systematic age. From the second instant of historical time, two kinds of behavior have been possible. Ever since then, most actions are ritual repetitions and very few are unprecedented.

Things, which may be compared to fossil actions, display several kinds of simultaneity. A Visigothic relief carving from Spain and a Maya stela were made during the same year in the sixth century A.D., and they are totally unrelated, but they are simultaneous. The Visigothic work belongs to a new series; the Maya stela pertains to a very old one. At the other extreme of relatedness, Renoir and Picasso in Paris about 1908 knew each other's work; Renoir's pictures then belonged to an old class and Picasso's early Cubist pictures belonged to a new one. These pictures are simultaneous and related, but they have different systematic ages, looking as different as the unrelated Maya and Visigothic sculptures. The similarities between Late Hellenistic architecture at Baalbek and Roman Baroque churches long ago captured the attention of historians, like those between different kinds of archaic art and the different kinds of antique revival.

Hence systematic age differentiates things as sharply as any other historical or geographical differences.

The presence of such a systematic age for the entire complex of manufactures in a civilization has long been obscured by several blinds. The temptation to interpret social processes from potsherds and broken stones has also been irresistible, and we are presented with cycles of political revolution, based on evidence which really speaks best of other things. Potsherds and broken stones are classes of effort that reflect political life from vast distances, no more strongly than when we faintly hear the dynastic conflicts of medieval France in Provençal poetry.

Each poem in an anthology of related verse has its own systematic age, like each pot in a museum series, and each piece of sculptured stone. Politics and civilizations probably can be ranked by their systematic ages. There is surely a systematic age independent of absolute age for the entire phenomenon of human civilization, which has endured for far less time than humanity, in an open sequence that includes the entire history of things.

A Mexican paradigm. An instructive example of all these matters comes from the Spanish colonization of the Indian peoples of Mexico in the sixteenth century. The early churches for two generations after the Conquest were built mostly by Indian workmen under the supervision of European Mendicant friars.[19] They can be classed readily in early and late groups within the era of Mendicant rule in Mexico until 1570. The early churches have rib vaults, some of them resembling types disused in Europe since the twelfth century, and they bear a decoration of late medieval antecedents. The late group of churches displays much technical refinement in the construction of domical vaults like those then being built in Spain with a decoration of classicizing origins. The beginning date and the initial conditions are unequivocal, like the terminal date, when secular clergy effectively displaced the friars in Indian towns.

19. Robert Ricard, La *"Conquête spirituelle" du Mexique* (Paris, 1933) and G. Kubler, *Mexican Architecture of the Sixteenth Century* (New Haven, 1948).

The need was clear to all the European colonists: the spiritual conquest of the Mexican Indian required fine large churches and convent-schools. The continuing problem presented by this need was to train and supervise Indian labor in European habits of work. The series embraced Mendicant churches with the host of subordinate classes therein involved. From the Indian view, everything started as if from zero; the quarrymen had to be taught the use of metal tools; the masons had to be taught the principles and the technique of building arches and domes; the sculptors had to be taught Christian iconography and the painters had to learn the principles of European one-point perspective construction as well as the rendering of forms in graduated color to simulate their appearances in light and shade. Any Indian sense of need or problem surviving from pre-Conquest life was driven underground or out of existence. At the same time every evidence shows the Indian craftsmen eagerly turning to learn the superior techniques and representational habits of their European teachers.

Thus the Christian transformation of Mexican architecture contains at least three major patterns of change. Indian life manifests two of them: one is the abrupt abandonment of native habits and traditions, and the other is the gradual acquisition of the new European modes of production. The discards and the replacements happened at different speeds. The third pattern governs the European colonists themselves. The conquistadors were men of a generation already accustomed to eclectic variety in Spain: the architecture of their day was preponderantly late medieval: Renaissance innovations from Italy still were rare. The leading fashion of the years 1500 1520 was the early mode of that harsh and energetic ornament later to be designated as Plateresque, which the men of the time in Spain thought of as *a lo romano*. By 1550 a new architecture based upon the art of Vignola began to displace Plateresque ornament. The Escorial is its principal expression, but contemporary with the Escorial and near it at Segovia, work continued on the late medieval rib-

vaulted cathedral begun only in 1525. Certain masters and work-men participated in both edifices, working alternately in the gothicizing and in the Vignolan manners.

By this account the situation of sixteenth-century Mexican architecture seems very complicated; in another perspective, however, no historical crisis shared by so many millions of people has ever displayed its structure more simply or plainly. A great cultural distance separated native behavior and Spanish behavior in the 1520's. This distance is like that which separates Old Kingdom Egypt or Sumerian Mesopotamia from the Europe of Charles the Fifth. Such dizzying confrontations of altogether different stages of cultural development upon a continental scale characterize every colonial phase of modern European history with many different results, but the same mechanism of change is repeated in every instance.

In the grammar of historical change, the Mexican conquest is like a paradigm, displaying with unusual clarity all the principal properties of this fundamental mechanism. The traditional be-havior of a person or of a group is challenged and defeated. New behavior is learned from the victors, but during the learning period, the new behavior is itself changing. This pattern recurs in every crisis of existence. The minimal case probably concerns our use of words in daily speech, when we are invaded, as it were, by new behavior symbolized in a word of questionable propriety or authority, and must decide to use or reject the ex-pression and the behavior for which it is the symbol. On another scale of magnitude the crisis returns each year in women's fashions, and it happens in every generation, whenever an avant-garde successfully advances the new or untried solutions to cur-rent problems, and in every trivial daily confrontation of re-tarded and progressive solutions to the same problem. Here the terms "retarded" and "progressive" are descriptive: no judgment of quality is intended, for the terms only record the antithetic phases of any moment of change, by describing their anchorage in time as backward or forward looking.

Linguistic change. Recent discoveries in the study of language[20] have an important bearing upon our estimates of change in the history of things. Cognate languages which are not in close contact, like Portuguese and French, or Huastec and Maya, have changed gradually or "drifted" since the peoples were separated. Word changes in lists of selected basic meanings can be measured by simple statistical means. The surprising result is that linguistic change occurs at a fixed rate, and that the amount of linguistic change can be used as a direct measure of the antiquity of the separation of the peoples. Many hundreds of textual and archaeological verifications support the thesis of the regularity of linguistic change.

Historians are accustomed to think of cultural change as an irregular and unpredictable set of occurrences. Because language is an integral part of culture, it should share the irregularity and unpredictability of history. How then can we account for the unexpected regularity of linguistic change, and how does it affect our conception of historical change?

In the first place, the historian's idea of change is related to to the linguist's idea of "drift," exemplified by the progressive separation that widens between cognate languages. This "drift," produced by cumulative changes in the articulation of sounds, can be related in turn to the interferences that distort any audible communication. The telephone engineer calls such interferences "noise." "Drift," "noise," and change are related by the presence of interferences preventing the complete repetition of an earlier set of conditions.

Historical change occurs when the expected renewal of conditions and circumstances from one moment to the next is not completed but altered. The pattern of renewal is recognizable but it is distorted; it is changed. In history the interferences preventing the faithful repetition of any pattern are mostly beyond human control, but in language the interferences must be regu-

20. D. H. Hymes, "Lexicostatistics So Far," *Current Anthropology, 1* (1960), 3–44, and "More on Lexicostatistics," ibid., 338–45.

lated or communication will fail. "Noise" is irregular and unexpected change. The efficacy of language requires that it be reduced to a minimum. This is achieved by transforming irregularity into steady pulses that accompany the communication as a hum of fixed pitch and loudness. The rate of change in language is regular because communication fails if the instrument itself varies erratically. The "noise" of history is altered in language to the unobtrusive hum of steady change.

These recent developments in the historical theory of language require us to reconsider the position of works of art as historical evidence. Most kinds of historical happening are subject to incalculable interferences which deprive history of the scope of predictive science. Linguistic structures, however, admit only those interferences whose regularity will not interfere with communication. The history of things, in turn, admits more interferences than language, but fewer than institutional history, because things which must serve functions and convey messages cannot be diverted from these finalities without loss of identity.

Within the history of things we find the history of art. More than tools, works of art resemble a system of symbolic communication which must be free from excessive "noise" in the many copies upon which communication depends, in order to ensure some fidelity. Because of its intermediate position between general history and linguistic science, the history of art may eventually prove to contain unexpected potentialities as a predictive science, less productive than linguistics, but more so than can ever be possible in general history.

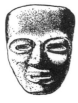 *3. The Propagation of Things*

It is a truism that the objects around us correspond to needs old and new. But this truism like others describes only a fragment of the situation. In addition to these correspondences between needs and things, other correspondences exist between things and things. It is as if things generated other things in their own images by human intermediaries captivated with those possibilities of sequence and progression we have just described. The sense of Henri Focillon's *Vie des Formes* captures the illusion of reproductive powers appearing to reside in things, and André Malraux later amplified the perception upon a much larger canvas in *Voices of Silence*. In this view the propagation of things may obey rules which we are now obliged to consider.

The occurrence of things is governed by our changing attitudes towards the processes of invention, repetition, and discard. Without invention there would be only stale routine. Without copying there would never be enough of any man-made thing, and without waste or discard too many things would outlast their usefulness. Our attitudes towards these processes are themselves in constant change, so that we confront the double difficulty of charting changes in things, together with tracing the change in ideas about change.

A signal trait of our own time is an ambivalence in everything touching upon change. Our whole cultural tradition favors the values of permanence, yet the conditions of present existence require an acceptance of continual change. We cultivate *avant-gardisme* together with the conservative reactions that radical innovation generates. By the same token the idea of copying is in disfavor as an educational process and as an artistic practice,

yet we welcome every mechanical production in an industrial age when the conception of planned waste has acquired positive moral value instead of being reprehensible, as it was during millennia of agrarian civilization.

INVENTION AND VARIATION

The antipodes of the human experience of time are exact repetition, which is onerous, and unfettered variation, which is chaotic. If deprived of customary behavior, as after the bombing of cities, people enter a state of shock, unable to cope with the invention of a new environment. At the other extreme of behavior, actuality becomes hateful within instants of our being deprived of the faculty of departing from past custom. The punishment of the prisoner lies in precisely this ironbound restriction to routine, which denies him the freedom to change external motions as he pleases.

Inventions, which are commonly thought to mark great leaps in development and to be extremely rare occurrences, are actually one with the humble substance of everyday behavior, whereby we exercise the freedom to vary our actions a little. We are only slowly emerging from the great romantic deformation of experience, when all the different skills and callings were costumed in fairy-tale parts, such as seven-league boots that allowed some to leap faster and farther than their plainshod contemporaries.

The innovator in any class rejoices in his familiarity with certain kinds of difficulties, and when he invents something, he is the beneficiary of what we have called a good entrance (pp. 6–7) as the first to perceive a connection among elements to which the key piece had only just come into view. Another could have done it as well as he, and another very often does, as in the celebrated coincidence of Charles Darwin and Alfred Wallace in respect to the theory of the origin of the species, because of similar training, equal sense of problem, and parallel powers of perseverance.

In our terms each invention is a new serial position. The acceptance of an invention by many people blocks their continuing acceptance of the preceding position. These blocks prevail only among closely related solutions in sequence, and they do not arise outside their own field of relevance, as we know from the coexistence at any instant of great numbers of active and simultaneous series (pp. 112 ff.). The products of prior positions become obsolete or unfashionable. Yet prior positions are part of the invention, because to attain the new position the inventor must reassemble its components by an intuitive insight transcending the preceding positions in the sequence. Of its users or beneficiaries the new position also demands some familiarity with prior positions in order that they may discover the working range of the invention. The technique of invention thus has two distinct phases: the discovery of new positions followed by their amalgamation with the existing body of knowledge.

The familiar delay between discovery and application reappears in every field of knowledge: the invention of oil painting occurred several times and at several places before fifteenth-century painters were ready to use it in panel painting. The discovery of metal tools can be ascribed in ancient America to several independent centers: the central Andes, c. 1000 B.C., Southern Mexico, after A.D. 1000, and the Great Lakes country of North America before A.D. 1000. Possibly southern Mexico learned from the Andean peoples: certainly the North American Indians discovered metals independently.[1]

When we imagine the transposition of the men of one age into the material setting of another, we betray the nature of our ideas about historical change. In the nineteenth century Mark Twain's Connecticut Yankee was imagined as a superior person successfully enlightening the Middle Ages. Today we would view him only as a stray spark swiftly extinguished without further notice.

1. P. Rivet and H. Arsandaux, *La métallurgie en Amérique précolombienne* (Paris, 1946).

An instructive fantasy is to imagine the exploration of a historical manifold of dimensions in which all times could coexist. If we might exchange information with men four hundred centuries before us, it is likely that the venture would result only in the enrichment of our knowledge of paleolithic life. Our skill at hunting large animals would appear worthless, and paleolithic men would have no use for anything of ours unrelated to his usual needs. If, on the other hand, we should ever have the misfortune really to encounter the future, as the Indians of sixteenth-century America encountered it, we would have to abandon all our own positions to accept all those of the conqueror.

In other words, our ability at any moment to accept new knowledge is narrowly delimited by the existing state of knowledge. A fixed ratio may mark the two kinds of knowledge. The more we know, the more new knowledge we can accept. Inventions lie in this penumbra between actuality and the future, where the dim shapes of possible events are perceived. These narrow limits confine originality at any moment so that no invention overreaches the potential of its epoch. An invention may appear to meet the edge of possibility, but if it exceeds the penumbra, it remains a curious toy or it disappears into fantasy.

Artistic invention. The discoveries and inventions of the past three centuries outnumber those of the entire previous history of mankind. Their pace and number continue to increase as if asymptotically towards a limit which may be inherent to human perception of the cosmos. How does artistic invention differ from useful invention? It differs as human sensibility differs from the rest of the universe. Artistic inventions alter the sensibility of mankind. They all emerge from and return to human perception, unlike useful inventions, which are keyed to the physical and biological environment. Useful inventions alter mankind only indirectly by altering his environment; aesthetic inventions enlarge human awareness directly with new ways of experiencing the universe, rather than with new objective interpretations.

Psychological science is more concerned with human faculties

as separate objects of study than as a single historically changing instrument of awareness. Aesthetic inventions are focused upon individual awareness: they have no therapeutic or explanatory purpose; they only expand the range of human perceptions by enlarging the channels of emotional discourse.

The late medieval invention of a pictorial language capable of representing all space on two dimensions, in northern Europe (Pol de Limbourg) and in Italy, was an aesthetic invention different from the technical invention of oil painting. A related effort in the twentieth century is still in progress to invent a language of expression that will be independent of images (abstract expressionism) and of fixed intervals (atonal music).

It does not follow that aesthetic invention is less important than useful invention because it concerns only an infinitesimal portion of the universe altered by useful invention. Human sensibility is our only channel to the universe. If the capacity of that channel can be increased, knowledge of the universe will expand accordingly. The channel may of course be augmented by many useful inventions; ultimately, however, every rational structure can be razed by adverse feeling. Emotions function like a main valve in the circuit between us and the universe. They may be artificially regulated by chemistry and psychiatry, but neither of these sciences can enlarge the instruments of aesthetic experience. Such enlargements always remain the prerogative of artistic invention.

In rough terms, artistic invention is one among many ways of altering the set of the mind, while useful invention marks out the scope of the knowledge the instrument was previously designed to encompass.

We have been using the terms of art and aesthetics almost as synonyms, for the reason that a clear separation such as the one between pure and applied science fails to appear in aesthetics. The significant gains are registered as art rather than as aesthetics. The separation between contemplative and practical labors that science requires has little meaning where art is concerned. Some

artists learn a theory of limits from aesthetics, but aestheticians learn little from art, being concerned more with philosophical questions than with artistic ones.

Indeed the work of many artists often comes closer to philosophical speculation than most aesthetic writings, which retrace the same ground over and over, sometimes systematically and sometimes historically, but rarely with originality. It is as if aesthetics had ceased since Croce and Bergson to be an active branch of philosophical speculation. The major artistic inventions, on the other hand, resemble modern mathematical systems in the freedom with which their creators discarded certain conventional assumptions, and replaced them with others. There has not been and there could not be any separation between theory and applications, or between inventor and user: both had to be one and the same person, so that at the beginning of these achievements the painter or the musician performed single-handedly all the functions elsewhere distributed among several persons in the search for new knowledge.

Returning now to the place of invention in the history of things, we confront once again the paradox which arose earlier in this discussion. It is the paradox of generalization concerning unique events. Since no two things or events can occupy the same coordinates of space and time, every act differs from its predecessors and its successors. No two things or acts can be accepted as identical. Every act is an invention. Yet the entire organization of thought and language denies this simple affirmation of non-identity. We can grasp the universe only by simplifying it with ideas of identity by classes, types, and categories and by rearranging the infinite continuation of non-identical events into a finite system of similitudes. It is in the nature of being that no event ever repeats, but it is in the nature of thought that we understand events only by the identities we imagine among them.

Convention and invention. In the daily behavior of Everyman, this paradox finds a constant expression. Since each act partakes of invention by departing from the preceding action in its class,

invention is open to everyone all the time. One result is that invention is misunderstood in two ways: both as a dangerous departure from routine, or as an unconsidered lapse into the unknown. For most persons inventive behavior is a lapse of propriety surrounded by the frightening aura of a violation of the sanctity of routine. They are so carefully schooled to convention that it is nearly impossible for them to fall even by accident into the unknown.

Many societies have accordingly proscribed all recognition of inventive behavior, preferring to reward ritual repetition, rather than to permit inventive variations. On the other hand no form of society ever can be devised to allow each person the liberty to vary his actions indefinitely. Every society functions like a gyroscope to hold the course despite the random private forces of deflection. In the absence of society and instinct, existence would float as if unbound by gravitation in a world without friction from precedent, without the attraction of example, and without the channeled pathways of tradition. Every act would be a free invention.

Thus the human situation admits invention only as a very difficult tour de force. Even in industrial societies which depend upon constant renewal by novelty, the very act of invention is distasteful to the majority. The rarity of invention in modern life corresponds to fear of change. The spread of literacy today is manifested not by a happy attention to new actions and new thoughts, but by stereotypes drawn from political propaganda or from commercial advertisements.

Both in science and in art the inventive behavior rejected by the mass of people has become more and more the prerogative of a handful who live at the crumbling edge of convention. Only exceptionally can any of these have an entrance allowing him to wander very far. A few in each generation arrive at new positions requiring the gradual revision of older opinions. The great mathematicians and artists, who stray farthest from usual notions, lead the procession. The chains of other inventors are measured

in much shorter lengths. Most of their inventions arise, like
rearranging the furniture, from new confrontations rather than
from fresh questions aimed at the center of being.

Indeed these alternatives mark the outlines of a typology of
inventive behavior. The more common category of inventions
embraces all discoveries arising from the intersection or con-
frontation of previously unrelated bodies of knowledge. The
intersection may bring a principle together with traditional
practices. Or the confrontation of several unrelated positions may
evoke a new interpretation clarifying them singly and together.
Whether extensions of a principle, or new explanatory principles
be the results of such intersections, they all arise from con-
frontations among elements already given to the observer.

A much rarer category of "radical" inventions discards these
ready-made positions. The investigator constructs his own sys-
tem of postulates and sets forth to discover the universe they
alone can disclose. The confrontation is between the new, un-
tried coordinates and the whole of experience: between untested
guide-lines and the evidence of the senses: between the unknown
and the familiar, the assumed and the given. It is the method of
radical invention, which differs from the other method of dis-
covery by confrontation, much as a new mathematical topic
differs from its applications.

If the difference between useful inventions and artistic in-
ventions corresponds to the difference between changing the
environment and changing our perceptions of the environment,
then we must account for artistic inventions in the terms of per-
ception. A special character of major artistic inventions resides
in their apparent remoteness from what has gone before them.
Useful inventions, when seen in historical sequence, show no
such great leaps or discontinuities. Every stage follows its prede-
cessors in a close-meshed order. Artistic inventions, however,
seem to cohere by distinct levels between which the transitions
are so difficult to identify that their existence may be questioned.

An important component in historical sequences of artistic

events is an abrupt change of content and expression at intervals when an entire language of form suddenly falls into disuse, being replaced by a new language of different components and an unfamiliar grammar. An example is the sudden transformation of occidental art and architecture about 1910. The fabric of society manifested no rupture, and the texture of useful inventions continued step by step in closely linked order, but the system of artistic invention was abruptly transformed, as if large numbers of men had suddenly become aware that the inherited repertory of forms no longer corresponded to the actual meaning of existence. The new outer expression with which we are universally familiar today in all the figurative and structural arts is an expression corresponding to new interpretations of the psyche, to a new attitude of society, and to new conceptions of nature.

All these separate renovations of thought came slowly, but in art the transformation was as if instantaneous, with the total configuration of what we now recognize as modern art coming all at once into being without many firm links to the preceding system of expression. The cumulative transformation of all being by useful inventions was a gradual process, but its recognition in perception by a corresponding mode of expression in the arts was discontinuous, abrupt, and shocking.

The nature of artistic invention therefore relates more closely to invention by new postulates than to that invention by simple confrontation which characterizes the useful sciences. Here we touch again upon the fundamental differences that separate prime objects from replicas. A prime object concerns radical invention, while the replicas vary from their archetypes by small discoveries based upon simple confrontations of what has already been done. Hence radical invention is most likely to occur at the beginning of a series; it is marked by many prime objects; and it resembles artistic creation more than it resembles scientific proof. As a series "ages," its primes are less numerous than at the beginning.

We may imagine the present instant as a smooth gradation between before and after, excepting when radical inventions and

prime objects make their presence known, like the infinitesimally small amounts of new matter created from time to time, with the tremendous energies of physical science. Their appearance in the texture of actuality forces the revision of all human decisions, not instantaneously but gradually until the new particle of knowledge has been woven into every individual existence.

REPLICATION

This age dedicated to change for its own sake has also discovered the simple hierarchy of the replicas that fill the world. We shall merely mention the staggering replication present in energy with only thirty some particles, or in matter which consists of about a hundred atomic weights, or in the genetic transmission of life, which since the beginning now comprises only about two million described species of animals.

The replication that fills history actually prolongs the stability of many past moments, allowing sense and pattern to emerge for us wherever we look. This stability, however, is imperfect. Every man-made replica varies from its model by minute, unplanned divergences, of which the accumulated effects are like a slow drift away from the archetype.

The term "replication" is a respectable old-fashioned word long in disuse, and we revive it here not only to avoid the negative judgment that adheres to the idea of "copying" but also to include by definition that essential trait of repeating events which is trivial variation. Since sustained repetition of any sort is impossible without the drift occasioned by tiny unwanted variations, this slow historical motion engages our main interest here.

Permanence and change. Let us imagine a duration without any regular pattern. Nothing in it would ever be recognizable, for nothing would ever recur. It would be a duration without measures of any sort, without entities, without properties, without events—a void duration, a timeless chaos.

Our actual perception of time depends upon regularly recur-

rent events, unlike our awareness of history, which depends
upon unforeseeable change and variety. Without change there
is no history; without regularity there is no time. Time and his-
tory are related as rule and variation: time is the regular setting
for the vagaries of history. The replica and the invention are
related in the same way: a series of true inventions excluding all
intervening replicas would approach chaos, and an all-embracing
infinity of replicas without variation would approach formless-
ness. The replica relates to regularity and to time; the invention
relates to variation and to history.

Human desires in every present instant are torn between the
replica and the invention, between the desire to return to the
known pattern, and the desire to escape it by a new variation.
Generally the wish to repeat the past has prevailed over the im-
pulses to depart from it. No act ever is completely novel, and no
act can ever be quite accomplished without variation. In every
act, fidelity to the model and departure from it are inextricably
mingled, in proportions that ensure recognizable repetition, to-
gether with such minor variations as the moment and the circum-
stances allow. Indeed, when variation from the model exceeds
the amount of faithful copying, then we have an invention.
Probably the absolute amount of replication in the universe ex-
ceeds the variations, for if it were otherwise, the universe would
appear more changeable than it does.

The anatomy of routine. Replication is similar to cohesion.
Every copy has adhesive properties, in holding together the
present and the past. The universe keeps its form by being per-
petuated in self-resembling shapes. Unlimited variation is a syno-
nym for chaos. The number of ritual acts in Everyman's life
greatly exceeds the few variant or divergent actions permitted
in his daily round. Indeed the cage of routine binds him so
closely that it is almost impossible for him to stumble into an
inventive act: he is like a tight-rope walker whom vast forces
so bind to the cable that he cannot fall, even if he wishes, into
the unknown.

Every society binds and shelters the individual within an invisible many-layered structure of routine. As a single entity he is surrounded by the ceremonial duties of physical existence. Another less dense shell of routine binds him and protects him, as a participant in the life of a family. The group of families makes a district; the districts make a city; cities form a county; counties make a state; states compose a civilization. Each successively more open layer of routine further shelters the individual from disruptive originality. The total structure, while remaining many-centered, protects each person with many layers. Some persons have fewer shells of routine, but none is entirely exempt. The entire system of these interlocking, reciprocally supporting routines of course drifts and sways, and swells and shrinks, in response to many conditions, not the least of which is inherent in duration itself, as we observe whenever a variant introduced for variety's sake and for no other reason appears in the texture of a repetitive act: the bored scribe introduces secret variations into the many copies of the invitation he must pen.

The foregoing remarks describe only a cross-section of the habitual actions holding societies together. There is also another dimension, composed of successive repetitions of the same acts. Each act varies slightly from the preceding. The successive versions—with gradual changes of which some are independent of external causes, occasioned only by the makers' craving for change, throughout long periods of repetition—describe distinct patterns in time of which we shall here attempt a rough description and a classing (p. 96). The identification of these fibrous durations of behavior is not easy: beginnings, endings, and boundaries are most elusive, and their determination perhaps requires a special geometry of which the rules still are not available to historians.

Recognizable behavior is recurrent behavior, but any study of behavior immediately brings us to the unresolved question: what are the fundamental units of behavior, and how numerous are they? Because of the restriction to things, our field is greatly

simplified in being reduced to the physical products of behavior, which allow us to substitute things for actions. The field of study still remains unmanageably complex, yet we are now enabled to view fashion, eclectic revival, and Renaissance as related phenomena of duration. Each of them requires large numbers of ritual gestures, which ensure participation with an admired society, but each occupies a different typical duration (p. 99).

Our conception of the copy now includes both acts and things. Under the rubric of actions we examined repetition in general, including habits, routines, and rituals. Among things (which differ as approximate and exact duplicates) our attention turns to copies and replicas. Symbolic associations, however, attach both to things and to actions. A symbol exists by virtue of repetitions. Its identity among its users depends upon their shared ability to attach the same meaning to a given form. The person using a symbol does so in the expectation that others will enlarge the association as he does, and that the resemblances between people's interpretations of symbols will outweigh the differences. Indeed it is unlikely that any copy ever passes as such without a great deal of assistance from symbolic associations. For example, in 1949 when I produced a photograph of him for a Peruvian mountain shepherd at Vicos, who had never seen a photograph, he was unable to orient the flat, spotty paper or to read it as a self-portrait, for want of those complicated habits of translation which the rest of us perform from two to three dimensions without effort.

In this perspective all things and acts and symbols—or the whole of human experience—consist of replicas, gradually changing by minute alterations more than by abrupt leaps of invention. People have long assumed that only the large changes were significant, like those represented by great discoveries, as of gravitation or the circulation of the blood. The little changes separated by infinitesimal alterations like the changes appearing in copies of the same document prepared by different scribes, are dismissed

as trivial. By the interpretation offered here, large-interval changes are similar to small-interval changes. Furthermore, many changes assumed to be large are really small when seen in full context. Thus a historian collecting the information gathered by others, is enabled to reinterpret the entire body with a more satisfying explanation, for which the entire credit attaches to his name, although his personal contribution is only of the same order of magnitude as that of the single units of information on which the theory itself rests. Hence a difference traditionally assumed to be one of a kind may be a difference only of degree.

The limits to our organic situation are very narrow. Too cold, or too hot, too little air, or too much bad air, and we die. Our tolerances for many other modes of variation are probably also small, with the present moment serving as an extremely minute valve regulating the amount of change admitted into reality.

Since the universe remains recognizable from one moment to the next, each instant is nearly an exact copy of the one immediately preceding it. The changes which occur are small relative to the whole, and they are proportional to the magnitude we assume for momentary duration. The idea corresponds to our direct experience: from this instant to the next the motions of the universe will not change greatly, but during the next year the course of happening will have altered direction many times. Large historical changes occupy large durations. If the accountancy is properly conducted, no great event can be assigned to brief times, although the traditional terms of speaking about the past often require us to think and behave as if history consisted only of great, brief instants separated by wastes of empty duration.

Historical drift. Certain types of motion appear when we look at time as an accumulation of nearly identical successive moments, drifting by minute changes towards large differences amassed over long periods. Motion is perhaps a misnomer for the changes occurring between early and later members of a series of replicas. Yet a series of objects, each made at a different time, and all

related as replicas based upon the same original form, describe through time an appearance of motion like that of the frames of a film, recording the successive instants of an action, which produce the illusion of movement as they flicker past the beam of light.

Replication obeys two contrasting kinds of motion. They may be described as motions towards and away from quality. Augmented quality is likely when the maker of a replica enriches upon his model by adding to its excellences, as when a talented pupil improves upon his mediocre teacher's exercises, or when Beethoven enriches Scotch songs. Diminished quality becomes apparent when the maker reduces the excellence of the replica, either because of economic pressures or because of his inability to comprehend the full scope or import of the model. Peasant replicas of court furniture and dress; paintings which are copies by untalented pupils; provincial series of constantly coarsened replicas of replicas are all examples of diminishing quality. Industrial examples are more common. When a mass-produced article of good design begins to have a wider market and more intense competition, the manufacturers simplify its design to get the price down until the product is reduced to the fewest possible parts in a construction no more durable than necessary. Hence loss of quality has at least two different velocities: one provincial, leading to coarseness, and the other commercial, leading to tawdriness. Provincialism and commercialism thus are related as kinds of qualitative degradation.

Some five thousand years ago there were no great cities and no far-flung trade, but only farming or fishing villages. The human community achieved both provincial and commercial distinctions only much later. The record of these earlier periods shows much less gradation in quality than the works of today. The pottery objects of one village differed little from one another within the span of a generation, and it is only across longer periods that we begin to see the interplay of regional traditions with positions upon the scale between early and late

manufactures in the same series. The idea of metropolitan or centrally influential events, as well as the idea of an excellence depending upon old and stable craft traditions, probably entered human consciousness only with the appearance of cities and with economic differences allowing the creation of luxuries by special artisans. Provincial degradation is surely older than commercial vulgarization. But village monotony remains the oldest of all the qualitative grades of civilized life.

DISCARD AND RETENTION

Change is occasioned by the many ways in which entities join and separate. Actuality concerns their instantaneous arrangement, and history treats of their successive positions and relationships. The different positions of human entities suggest a category of forces for which we have no other name than *needs*. Discard and retention belong with other processes to this field of forces—a field where appetite and repletion, pleasure and revulsion, are the poles.

The decision to discard something is far from being a simple decision. Like each fundamental type of action, it appears in the experience of every day. It is a reversal of values. Though the thing once was necessary, discarded it becomes litter or scrap. What once was valuable now is worthless; the desirable now offends; the beautiful now is seen as ugly. When to discard and what to discard are questions to which the answers are governed by many considerations.

Obsolescence and ritual. The usual view in our age is that obsolescence is merely an economic phenomenon occasioned by technical advances and by pricing. The cost of the maintenance of old equipment outruns the cost of its replacement with new and more efficient items. The incompleteness of this view is apparent when we consider the decision not to discard.

For example, one important way of retaining the products of the past occurs in the elaborate tomb furniture of some peoples,

whose firm belief in an after-life was of course a main motive for the immense funeral deposits in Egyptian, Etruscan, Chinese, or Peruvian burial grounds. We are at liberty to suppose that the craftsmen in these societies were excessively numerous in relation to princely demands upon their skill. The corollary is that the production of precious things far exceeded the rate of their disappearance by normal wear and breakage.

The idea of elaborate tomb furnishings then would have achieved several objectives: to preserve past remains with due piety while avoiding the contagion of handling the things of dead people, as well as to withdraw old-fashioned objects from daily use and thereby to stimulate new manufactures for living use. Tomb furniture achieved apparently contradictory ends, in discarding old things all while retaining them, much as in our storage warehouses, and museum deposits, and antiquarians' storerooms. There, huge accumulations await a return to use which depends both upon increasing rarity and upon future changes of taste.

Here is a possible reason why the rate of technological change was so slow until a century or so ago. When the making of things required a very large effort, as in pre-industrial life, it was easier to repair them than to discard them. The opportunities for change were correspondingly fewer than in an industrial economy, where mass production permits the consumer to discard equipment regularly. Because each change suggested by invention required too great a sacrifice of the existing equipment, it could enter reality only when the offending conventions, habits, and tools dropped unnoticed out of regular use. In other words, the need to retain things may have governed the rate of change in human manufactures more than the desire for novelty.

In the conception of systematic change, every action belongs in a series of similar actions. By hypothesis, all such similar actions are linked as model and copy. The copies vary by minute differences. In every series early actions differ from late ones. The recognition of these series often is hindered by many kinds of

outside interference, as well as by uncertainties about the morphology of early and late actions. Further uncertainty surrounds the analysis of any action into serial components of which some are old behavior and others are new. But if our hypothesis holds, then we must add to any external explanations of any part of behavior, some account of the behavior in respect to its seriation.

Establishing chronological order is not enough, for absolute chronology merely arranges the moments of time in their own sidereal succession. The perpetual problem confronting the historian has always been to find the beginning and the end of the threads of happening. Traditionally he has cut the thread wherever the measures of narrative history indicated, but those cuts have never taken as a possible measure the differences between different lengths in specific duration. The discovery of these durations is difficult, because only absolute chronology can now be measured: all past events are more remote from our senses than the stars of the remotest galaxies, whose own light at least still reaches the telescopes. But the moment just past is extinguished forever, save for the things made during it.

In the subjective order an act of discard relates to the ends of durations, just as an act of invention initiates them. It differs from other kinds of rupture (p. 109) as a free decision differs from an imposed one, or as a slowly accumulated resolve differs from an unprepared action in an emergency. The act of discard corresponds to a terminal moment in the gradual formation of a state of mind. This attitude is compounded of familiarity and discontent: the user of an object knows its limitations and its incompleteness. The thing meets only a past need without corresponding to new needs. The user becomes aware of possible improvements in merely noting the lack of correspondence between things and needs.

Discarding useful things differs from the discard of pleasurable things in that the first operation is more final. The breakup of old tools has often been so complete that practically nothing survives of the equipment of many epochs, save a few images

and ceremonial versions of the metal instruments which were melted down when new forms were needed. A main reason for this pitiless scrapping of the tools of the past is that a tool usually has but one single functional value.

An object made for emotional experience—which is one way of identifying a work of art—differs from a tool by this meaningful extension beyond use. Because the symbolic frame of existence changes much more slowly than its utilitarian requirements, so the tools of an era are less durable than its artistic productions. It is much easier to reconstitute a symbolic facsimile of medieval life with a small museum of manuscripts, ivories, textiles, and jewelry, than to attempt to describe feudal technology. For the technology, we have only suppositions and reconstructions. But for the art we have the objects themselves, preserved as symbols which still are valid in actual experience, unlike the superannuated discards of medieval labor.

The retention of old things has always been a central ritual in human societies. Its contemporary expression in the public museums of the world rises from extremely deep roots, although the museums themselves are only young institutions going back to the royal collections and the cathedral treasuries of earlier ages. In a wider perspective the ancestor cults of primitive tribes have a similar purpose, to keep present some record of the power and knowledge of vanished peoples.

Aesthetic fatigue. The point of these distinctions is that merely useful things disappear more completely than meaningful and pleasurable things. The latter seem to obey a more lenient rule of discard. This rule corresponds to a state of mental fatigue, signifying a jaded familiarity more than muscular or nervous exhaustion. *Déjà vu* and *trop vu* are equivalent expressions in French criticism for which no current English phrase exists, unless it be tedium. Its nature and conditions first attracted attention in 1887, when Adolf Göller wrote on fatigue (*Ermüdung*) as it affected the many changes of architectural style that were so

striking when eclectic taste was dominant.[2] They were striking, not because architectural change was then more rapid than it is today, but because there were only a few historic styles to choose from, and it seemed to the men of the period that they were rapidly exhausting these reserves of the past.

Göller, an architect and professor at the Polytechnikum in Stuttgart, was an early psychologist of artistic form who belonged to the tradition of abstract formalism in aesthetics initiated by Herbart. Since about 1930 Göller's expression, *Formermüdung*, has come into wider use, although no one has pursued his ideas any farther. To Göller architecture was an art of pure visible form. For him its symbolic content was negligible, and its beauty arose from a pleasurable but meaningless play of line, light, and shade. Göller's principal hope was to explain why the sensations of optical pleasure are in constant change as manifested in the sequence of styles. The nucleus of Göller's thought is that our delight in pleasurable forms arises from the mental effort of shaping their recollection. Since all mental knowledge consists of such memory residues, the enjoyment of beautiful forms requires a well-stocked memory. Taste is a function of familiarity. Our pleasure in pure form diminishes as we succeed in reconstituting its complete and distinct memory. A total memory presumably includes the frustrations and dissatisfactions arising with any recurring unit of experience: "familiarity breeds contempt." These total recollections occasion fatigue, and they lead to the search for new forms. As the mind fastens upon content, however, the rule of *Formermüdung* weakens, and the object holds our attention in proportion to the complexity of its meaning.

2. I first became aware of A. Göller in tracing the origin of *Formermüdung*. His short essay, "Was ist die Ursache der immerwährenden Stilveränderung in der Architektur?" in *Zur Aesthetik der Architektur* was amplified one year later as *Entstehung der architektonischen Stilformen* (Stuttgart, 1888). Benedetto Croce mentioned Göller only to reject his empirical and formalistic tendencies (*Età barroca* [Bari, 1929], p. 35), but *Wasmuth's Lexikon der Baukunst*, 2 (1930), 653, noted Göller's strong influence upon the architectural thought of his own day.

The artist himself is most exposed to tedium, overcoming it by the invention of new formal combinations and by more daring advances in previously established directions. These advances obey a rule of gradual differentiation because they must remain as recognizable variations upon the dominant memory image. The differentiations are bolder among young designers, and their tempo becomes more rapid as a style approaches its end. If a style is interrupted early for any reason, its unused resources become available for adaptation by participants in other styles.

The work of the human mind cannot be accounted for by any isolated process. Göller underestimated other forces in the complex interplay of actuality and the past, and he lacked an explicit conception of the tradition-forming power of replication, or of the human requirement for variety, which is satisfied by inventive behavior. Yet despite his exaggerated insistence upon tedium or fatigue as the sole motive force driving designers from fully mapped positions to less well charted ones, Göller clearly thought of art as consisting of linked series of forms, which differ gradually from one another until the potentialities of the class have been used.

4. Some Kinds of Duration

The modern professional humanist is an academic person who pretends to despise measurement because of its "scientific" nature. He regards his mandate as the explanation of human expressions in the language of normal discourse. Yet to explain something and to measure it are similar operations. Both are translations. The item being explained is turned into words, and when it is measured it is turned into numbers. Unfortunately the tissues of history today have only one dimension that is readily measured: it is calendrical time, which permits us to arrange events one after another. But that is all. The domain of the historical sciences remains impervious to other numbers. We can nevertheless use the language of measurement without numbers, as in topology, where relationships rather than magnitudes are the subject of study. Calendrical time indicates nothing about the changing pace of events. The rate of change in history is not yet a matter for precise determinations: we will have advanced if only we arrive at a few ideas about the different kinds of duration.

The history of things is about material presences which are far more tangible than the ghostly evocations of civil history. The figures and shapes described by the history of things are moreover so distinctive that one asks whether artifacts do not possess a specific sort of duration, occupying time differently from the animal beings of biology and the natural materials of physics. Durations, like appearances, vary according to kind: they consist of characteristic spans and periods, which our generalizing habit of language makes us overlook, since we can

transform them so easily into the common currency of solar time.

FAST AND SLOW HAPPENING

Time has categorical varieties: each gravitational field in the cosmos has a different time varying according to mass. On earth at the same instant of celestial time, no two spots really have the same relation to the sun despite our useful convention of time-zones regulating the regional concordance of clocks. When we define duration by span, the lives of men and the lives of other creatures obey different durations, and the durations of artifacts differ from those of coral reefs or chalk cliffs, by occupying different systems of intervals and periods. The conventions of language nevertheless give us only the solar year and its multiples or divisions to describe all these kinds of duration.

St. Thomas Aquinas speculated in the thirteenth century upon the nature of the time of angels, and, following a neo-Platonic tradition,[1] he revived the old notion of the *aevum* as the duration of human souls and other divine beings. This duration was intermediate between time and eternity, having a beginning but no end. The conception is not inappropriate for the duration of many kinds of artifacts—so durable that they antedate every living creature on earth, so indestructible that their survival may, for all we know, ultimately approach infinity.

Confining our attention to the history more than the future of man-made things, what conditions must we take into account to explain the variable rate of change? The social scientists describe material culture as an epiphenomenon, that is, as the necessary result of the operation of forces which the social scientists have already formulated and charted. For instance, small societies dispose of less energy than large ones, and they are consequently less able to initiate costly enterprises. Such quantitative

1. Duhem, "Le temps selon les philosophes hellènes," *Revue de philosophie* (1911).

assessments of cultural effort permeate sociology, anthropology, and economics. One example is the economic explanation of the position of the artist and designer in twentieth-century industrial life. To the economist artifacts change according to the market: a falling or rising demand for an article affects the volume of production; opportunities to change the product vary with production.

But our earlier distinction between prime objects and replica-masses suggests another line of argument. The existence of masses of copies testifies to a large public, which may desire or condemn change. When change is wanted, the public itself requires only improvements or extensions upon the actual product. Public demand recognizes only what exists, unlike the inventors and artists whose minds turn more upon future possibilities, whose speculations and combinations obey an altogether different rule of order, described here as a linked progression of experiments composing a formal sequence.

This separation between designer and consumer of course does not hold in many kinds of society, where most objects are made in the family circle. But the division by prime objects and replica-masses holds for peasant society as well as for the tribal compound and the courts of eighteenth-century Europe. There can be no replica without an original; and the family of originals takes us back directly to the genesis of human society. If we wish to explore the nature of change, we must examine the sequence of forms.

The replicas may directly reflect such magnitudes as wealth, population, and energy, but those magnitudes do not alone account for the incidence of the original or prime expressions from which the replicas derive. Prime expressions in turn occur in formal sequences. This conception supposes that inventions are not isolated events, but linked positions of which we can trace out the connections. The idea of seriation also presupposes a structural order in the sequence of inventions which exists independently of other conditions. The order of realization may

be deformed, and the sequence may be stunted by outside conditions, but the order itself is not the consequence of such conditions. Under certain circumstances an inherent structural order in the sequence of new forms is easily apparent to many observers: we perceive it most clearly in the early stages of Greek figural sculpture, Gothic architecture, and Renaissance painting, where linked runs of related solutions follow one another in a recognizable order as if following out the conditions of a prior program common to these various evolutions.

Runs of this type are nevertheless far from common. Because of the completeness of the inventory of the European past they come into view more frequently there than on other continents. But their appearances are widely separated, as if events of this magnitude could not recur frequently. Perhaps they are like the *aurora borealis,* best noted at some latitudes rather than others, as field manifestations visible only under special conditions.

The typology of artists' lives. More readily available for observation are the lives of famous artists. The pace and tone of an artist's life can tell us much about his historical situation, although most artists' lives are uninteresting. They fall usually into routine divisions: apprenticeship, early commissions, marriage, family, mature works, pupils, and followers. Sometimes the artist travels, and occasionally his path crosses those of more colorful persons. Cellini, who was not an interesting artist, led an exciting life, which kept him from the difficult business of art.

The individual in search of a personal expression, when confronted with the local stock of possibilities available to him upon his entrance, must select the components he will use. This gradual accommodation between temperament and formal opportunity defines the artistic biography. Our evidence is limited to careers that have withstood the assaults of time: we have only the "successful" outcomes to all these chancy adjustments between the individual and his moment, and from them all only a few types emerge, of which our knowledge is confined to Europe and the

Far East. As a literary genre, artistic biography was not practiced elsewhere.

By definition a formal sequence exceeds the capacity of any individual to exhaust its possibilities in one lifetime. He can nevertheless imagine more than he can execute. What he executes obeys a rule of sequence in which the positions but not the intervals are determined. Both what he imagines and what he executes depend upon his position in the sequence, upon his entrance into the form-class (p. 33). An affinity exists between each of these opportunities and the corresponding human temperament.

There are slow-paced, patient painters, such as Claude Lorrain and Paul Cézanne, whose lives contain only one real problem. Both men were alike in their dedication to the portrayal of landscape and they were alike in finding outmoded teachers for their effects. By relying upon his Bolognese predecessors, Domenichino and the Carracci, Claude renovated the landscape of Romano-Campanian antiquity. Cézanne turned to Poussin, like so many French painters with an interest in tectonic order. The resemblances are not mere biographical coincidences nor are they temperamental affinities alone. The anonymous mural painters of Herculaneum and Boscoreale connect with those of the seventeenth century and with Cézanne as successive stages separated by irregular intervals in a millenary study of the luminous structure of landscape, which probably will continue for many generations more upon equally unpredictable rhythms. The type flourishes only in those urbane periods when the ascendancy of special vocations allows persons of a ruminative tendency the leisure to achieve their difficult varieties of excellence.

Under these conditions, and for as long as the old pictures or their derivatives survive, painters of a certain temperament will feel summoned to meet their challenge with a contemporary performance. Ingres continued upon the lines marked by Raphael;

Manet accepted the challenge put before him by Velázquez. The modern work takes its measure from the old: if it succeeds, it adds previously unknown elements to the topography of the form-class, like a new map reporting unexpected features in a familiar but incompletely known terrain. Sometimes the map seems finished: nothing more can be added; the class of forms looks closed until another patient man takes a challenge from the seemingly complete situation, and succeeds once more in enlarging it.

Altogether different from these ruminative artists of a single problem are the versatile men. Their entrances may occur at either of two junctures, of social or technical renovation. The two kinds sometimes coincide, as in the Renaissance. Technical renovation is like a spring thaw: everything changes at once. Such moments in the history of things occur when new techniques suddenly require all experience to assume their mold: directors of cinema, radio, and television have thus transformed our world in this century, and the Vasari who should find his entrance ready for him about a generation from now, will then record and magnify these legendary figures of sound and shadow whose myths already rejoin those of classical antiquity.

The other moment for the appearance of the versatile men occurs when a whole society has been resettled along new lines of force after great upheavals, when for a century or two the endlessly complicated consequences, implications, and derivations of novel existential assumptions must be set in order and exploited. The greatest concentration of these versatile artists appears in Renaissance Italy, where they flourished as a recognizable social type under the patronage of merchant princes and small nobility, of popes and *condottieri*. Alberti, Leonardo, and Michelangelo are its most celebrated Italian representatives; Jefferson was an even rarer type, the artist-statesman.

These epochs of social displacement when new masters take control are of course not always periods of artistic renewal. The revolutionary transformation of French national life at the close

of the eighteenth century witnessed new and striking fashions, but there was no fundamental artistic renovation comparable to that of the fifteenth century in Italy. In general, this renewal has to occur in works of art and among groups of artists, and it cannot come from government decrees. There need be no renovation at times when ample future scope still appears in the current traditions. As the versatile man is called into being by the time of renovation, so the patient student of single problems flourishes in a time of settled futurities.

It would be unhistorical to suppose that any period of time ever has a uniformly patterned structure such as the foregoing remarks are in danger of suggesting. But it is also unhistorical to represent a given period in the history of architecture, like the Periclean age, as a time of unpatterned or unlimited possibilities. Certain aims had already been accomplished, and the outlines of new possibilities were apparent. The men of the generation of Mnesicles had little choice but to move from the position just gained to the next position as it appeared to them from their vantage as professionals estimating the chances of success and failure among the public of the day.

A very few versatile men with favorable entrances also have in common the ability to assume in rapid succession a large number of the available positions and thus to anticipate their successors for several generations, even adumbrating another new series before the one in which they are engaged has been played out. Michelangelo is the most notable of these proleptic artists; Phidias may have been another. Such men prefigure in the work of a few years the series that several generations will slowly and laboriously evolve: they are able by an extraordinary feat of the imagination to anticipate a future class of forms in relatively complete projection. The feat is not easily visible to their contemporaries. It appears more clearly to historians with panoramic hindsight, long after the event. It induces the idea that change can be brusqued into premature readiness by the action of such exceptional individuals.

Certain other biographical patterns among artists can be identi-
fied. The number is small, perhaps only because so few biog-
raphies of the world's artists and artisans are preserved, but more
likely because the variation of type is inherently small among
the lives of inventive persons. Thus Hokusai resembles Uccello
as an obsessive painter of a type to which Piero di Cosimo,
Rembrandt, and Van Gogh also belong as lonely and withdrawn
men to whom painting was a complete life. They are neither
ruminative and patient, nor versatile and proleptic, but solitary
men who totally occupy the positions given them upon their
particular entrances. Even architects, whose work demands gre-
garious virtues, can be found among their number: the careers
of Francesco Borromini and Guarino Guarini belong to this ob-
sessive group by the strange, intense, and complete reality with
which they clothed their lonely, imaginary worlds.

A contrasting type is the evangelist whose mission is to im-
prove the visible world by the imposition of his own sensibility.
No major architect of the present century has been able to practice
without assuming this evangelical garb. The missionary-artist
is often a vigorous teacher and a prolific writer flourishing best
when he is in command of academies of right practice. J.-A.
Gabriel, the leader of French architectural taste, or Frank Lloyd
Wright and Sir Joshua Reynolds are examples. Each of them
exercised an autocratic taste, founded upon selected conventional
traits, which the older men took from an aristocratic tradition,
and which Wright took from H. H. Richardson and Louis
Sullivan.

Two distinct kinds of innovators occur in the history of art.
The rarest of them are the precursors, like Brunelleschi, Masaccio,
or Donatello, whose powers of invention find a proper entrance
no oftener than once every few centuries, when new domains of
knowledge are opened through their efforts. The other kind is
the rebel who secedes from his tradition the better to have his
own way either by altering its tone like Caravaggio, or by
challenging its entire validity, like Picasso. The precursor may

also be a ruminative or an obsessed artist like Cézanne. Without being a rebel the precursor quietly lays new foundations within an old preserve. The precursor can have no imitators: he is always *sui generis,* while the rebel appears in crowds, because the way of the rebel is easily imitated. The precursor shapes a new civilization; the rebel defines the edges of a disintegrating one.

The genuine precursor usually appears upon the scene of a provincial civilization, where people have long been the recipients rather than the originators of new behavior. The rebel like Picasso finds his situation at the heart of an old metropolitan civilization. The necessary condition for a precursor is that his activity be new; for a rebel that his be old. Precursors have to mold their work in the shell of an older guild, like Ghiberti, who was apprenticed as a goldsmith, or find a place for it at the bottom of society like the creators of the early cinema. The rebels, on the other hand, who shape their lives on the fringes of a society they despise, have to form a new civil condition in the pursuit of some integrity of life and work. Gauguin's is the most celebrated example, in the special form of the artist as a bourgeois refugee continuing the romantic convention of Parisian bohemianism among primitive villagers in Tahiti.

These six types of careers: precursors, *hommes à tout faire,* obsessives, evangelists, ruminatives, and rebels all exist at once in modern occidental society. Of course they cannot all occupy the same formal sequences. Each sequence affords the opportunities of its particular systematic age to only that group having the temperamental conditions for a good entrance. Thus television calls upon a special temperamental class for its directors today, but it will require another kind of temperament in a later decade, while the men then who might have been television directors today, may turn to another theatrical form which will be more prepared to give them their entrances.

As we look at other societies and at earlier times, it becomes impossible to document the existence of any variety of careers. The bohemian cannot be identified before the seventeenth cen-

tury in Europe or China. Indeed in older societies it is likely that the borderlines between careers were much less apparent than they are today, that ruminative and obsessed artists merged, like precursors and rebels, or versatile and evangelical men, without the clear separation noted today. In the Middle Ages the individual artist remains invisible behind the corporate façades of church and guild. Greco-Roman and Chinese histories alone report in any detail the conditions of individual artists' lives. A few names and lines of text are all we have about Egyptian dynastic artisans. The records of the other civilizations of antiquity in America, Africa, and India tell nothing of artists' lives. Yet the archaeological record repeatedly shows the presence of connected series of rapidly changing manufactures in the cities, and slower ones in the provinces and in the countryside, all manifesting the presence of persons whom we can call artists. They did not all flourish together at the same time as they do today in the great cities of the principal states, where more classes of forms coexist than there are talents to staff them. For instance, progressive painting today mainly attracts rebels, while the precursors and the ruminatives either paint as obscure men under a protective coloration that shields them from success, or they belong to other guilds like stage design or advertising art, where their peculiar dispositions are more urgently needed than in painting for fashionable dealers. In older societies, fewer sequences were in active development at one time, and the opportunities for the whole spectrum of temperaments were correspondingly more modest.

Tribes, courts, and cities. A provisional explanation of the fast and slow changes in the history of things now emerges. The intervention of men to whom art is a career, of men who spend all their time in the production of useless things, occasions the shift from slow to fast happening. In tribal societies of a few hundred families, where everyone must raise food most of the time by endless toil in a harsh environment, there is never enough margin beyond subsistence to allow the formation of those specialized

guilds of artisans who are exempted from growing food. In such societies the manufactures show change, it is true, but that change is the change of casual drift, of cumulative habit, of routine repetition with minor variations, which through the generations yield a characteristic pattern.

The pattern resembles that of the changes in the things made under more complicated social structures. It shows the expected progression from early to late systematic age within the different classes of pottery, housing, and ritual instruments. Distinct form-classes succeed one another. Within the scope of three or four generations a clear shape corresponding to the physical identity of the tribe can be detected by the attentive student. But the progression, the succession, and the shape all are more muted and less distinct than in larger societies, and the pace is slower. Less happens; fewer inventions occur; and there is little conscious self-definition of the tribe by its manufactures.

This contrast selects only extreme cases—the tiny tribe of a few scores of families struggling to survive, and the vast metropolis with its crannies and ledges sheltering the meditations of many inventive minds—to exemplify the most sluggish and the most vertiginous kinds of change. Between them are at least two intermediate positions. It is too simple to suppose that the gradient is a continuously smooth one. Between London or Paris, and the forest tribes of Amazonia or New Guinea, the gradations of social organization are far from continuous; they are more like a mountainous escarpment with bold high tiers of cliffs separating several terraces.

Absolute demographic size is irrelevant. Small cities have generated the principal events of history more often than the megalopolis. An urban setting is a necessary if inadequate condition for the occurrence of fast happening. The setting is urban when the privileged city dwellers are not a self-sufficient tribe but a group of rulers, artisans, merchants, and parasites dependent upon the labor of food-growing rural populations scattered throughout the countryside.

Urban life alone is not enough. The provinces all have cities, but the tedium of provincial city life is proverbial. It is tedious because the provincial city is like an organ that usually can only receive and relay messages from the higher nervous centers: it cannot issue many messages of its own, other than of pain or discomfort; and its active elements perennially emigrate to the true centers of happening, where the central decisions of the whole group are made, and where the concentration of power draws together a class of patrons for the inventions and designs of the artist. These are true metropolitan conditions. They are the only necessary and adequate conditions for the appearance of the rapid historical pace that has always marked life in the chief cities of man.

Thus we have four societal phases to consider in this discussion of the velocity of artistic events: (1) tribal life, face-to-face with nature and unable to afford artisans; (2) provincial towns and cities with their derivative arts, including those capital cities which specialize only in government; (3) tribal societies that include professional craftsmen with originating powers; (4) cities or courts which issue the invisible yet ultimate orders. The tabulation pertains to Greco-Roman civilization, to Chinese dynastic society, and to the modern world since 1800 with its political division by ruling states and colonial empires, and by capital cities drawing to themselves the flower of provincial talent. It is valid also for the urban civilizations of ancient America. The ranking of provincial cities as less favorable environments than tribal societies which have their own craft traditions may seem arbitrary, but it is justified in regard to the conditions of original artistic activity: an Ashanti bronzeworker in mid-nineteenth-century Africa was perhaps more favorably situated as an artist than his contemporary colleagues in Chicago or Mosul, who were limited to the making of provincial replicas and useful stereotypes.

In medieval Europe before 1400 a different scheme is needed. The feudal courts, the abbeys, and the cathedrals were the

generating centers for important commissions; the surrounding countryside was the receiving province, and the larger cities depended upon the intermittent presence of the royal court for their access to favor and power. Following the Renaissance, the capital cities rose to greater importance, but until 1800 the many small princely courts of Europe were true centers of artistic excellence, taking only rarely a provincial relationship to the great cities, which often were themselves more provincial in certain respects than, for instance, the duodecimo duchy of Weimar which supported Goethe. Today the leveling of the world by mass entertainment and industrial monotony is so complete that only the richest cities and a few university towns remain as citadels of learning and discrimination.

The different historical climates of patronage afforded different settings for the six kinds of career we discussed earlier. The precursor and the rebel could have no place either in a tribal society or in provincial life where non-conformity leads to grave punishments. Only the richest centers of power can support the *homme à tout faire* or his academic counterpart, the evangelical *chef d'école*. The obsessed men and the ruminatives can work anywhere, but their training and formation require that they spend some time at court or near the sources of patronage to become part of the stream of fast happening.

In other words, there are only two significant velocities in the history of things. One is the glacier-like pace of cumulative drift in small and isolated societies when little conscious intervention occurs to alter the rate of change. The other, swift mode resembles a forest fire in its leaping action across great distances, when unconnected centers blaze into the same activity. The history of a recent invention has many instances of this apparent action at a distance, as when two or more professional men without knowledge of one another's work, come to the same solutions independently yet simultaneously, from common premises and similar method.

An important variant of fast happening can be described as

the pace of intermittent duration: a problem receives early attention, like Heron's steam engine, or Greco-Roman still-life painting. In the absence of supporting conditions and reinforcing techniques, the invention then languishes in obscurity for many centuries until those conditions are produced that allow the form class to reenter the inventive conscience of another civilization. This intermittent mode of happening has rapid instants, and it is confined to the principal centers of civilization, but it is irregular in pace, and its full consequences are extremely slow to be extracted.

The full range of artistic careers, from precursors to rebels, thus can unfold only under metropolitan conditions, when a wide selection of active sequences is available. Fast happening depends upon favorable conditions of patronage and career, while slow happening characterizes provincial or tribal settings where neither patronage nor possibilities of career exist to stimulate a more rapid exploration of the various classes of forms.

THE SHAPES OF TIME

The number of ways for things to occupy time is probably no more unlimited than the number of ways in which matter occupies space. The difficulty with delimiting the categories of time has always been to find a suitable description of duration, which would vary according to events while measuring them against a fixed scale. History has no periodic table of elements, and no classification of types or species; it has only solar time and a few old ways of grouping events,[2] but no theory of temporal structure.

If any principle of classing events be preferred to the impossible conception that every event is unique and unclassable, then it must follow that classed events will cluster during a given portion of time in an order varying between dense and sparse array. The

2. J.H.J. van der Pot, *De periodisering der geschiedenis, Een overzicht der theorieën* (The Hague, 1951).

classes we are considering contain events related as progressive solutions to problems of which the requirements are modified by each successive solution. A rapid succession of events is a dense array; a slow succession with many interruptions is sparse. In the history of art it occasionally happens that one generation, and even one individual achieves many new positions not only in one sequence but in a whole set of sequences. At the other extreme a given need will subsist for generations or even centuries without fresh solutions. We have already examined these occurrences under the heading of fast and slow happening. They have been explained as contingent upon position in the series and upon the varying pace of invention in different centers of population. Let us now look at further varieties in the array of serial positions.

Positional values. An *Apostolado* by Zurbarán is a unified and coherent work of art.[3] It consists of twelve or thirteen paintings that portray the apostles. Each picture can be seen alone, but the painter's intention and the patron's wish were to have the entire group seen together as a corporate work of art in a prescribed sequence and occupying a specified space. Many things have similar group properties which require them to be perceived in a predetermined order. Buildings in their settings are a sequence of spaces best seen in an order intended by the architect; the sculptured faces and separate parts of a public fountain or monument also should be approached as planned; and many paintings were originally meant each to have a fixed position in a sequence, from which a total narrative effect might arise.

In such corporate works of art, each separable part has a positional value in addition to its own value as an object. Usually our comprehension of a thing is incomplete until its positional value can be reconstructed or recovered. Hence the same thing can be quite differently valued as an object separated from context, and as a corporate work in its intended setting. Greco-Roman art

3. M. S. Soria, *The Paintings of Zurbarán* (New York, 1953), e.g. Nos. 78, 144, 145.

depends greatly upon positional values: Philostratus' *Imagines* and the contrasting pedimental narratives at Aegina or on the Parthenon are examples. Often the positional value adds to the interpretation, as when Old and New Testament stories are paired by the parallels, antetypes, and prefigurations that have been parts of Christian teaching since before Prudentius' *Dittochaeum*.[4]

To these obvious values accruing from spatial position we can add another category accruing from temporal position. Because no work of art exists outside the linked sequences that connect every man-made object since the remotest antiquity, every thing has a unique position in that system. This position is marked by coordinates of place, age, and sequence. The age of an object has not only the customary absolute value in years elapsed since it was made: age also has a systematic value in terms of the position of a thing in the pertinent sequence.

Systematic age enlarges our conception of historical position. The idea requires that we relate each thing to the several changing systems of forms in which its occurrence belongs. Hence the usual names of things are inadequate because they are too general. It is too broadly inclusive to speak of the systematic age of an English country house like Sevenoaks, built during many centuries; we can consider only its parts and the ideas for their unification when we establish systematic ages. A great stair, for example, if built in 1560 would be a very new form in its class, for great stairs began to be built in Spain and later in Italy no earlier than the opening years of the sixteenth century.[5] A remodeling in 1760 that imposed unsymmetrical, gothicizing variety upon an older house by John Webb (1611–74) was likewise very new in the form-class of picturesque architectural

4. K. Lehmann-Hartleben, "The Imagines of the Elder Philostratus," *Art Bulletin, 23* (1941), 16–44. A. Baumstark, "Frühchristliche-Palästinische Bildkompositionen in abendländischer Spiegelung," *Byzantinische Zeitschrift, 20* (1911), 177 ff.

5. N. Pevsner, *An Outline of European Architecture* (Baltimore, 6th ed., 1960), pp. 47–48 on square open-newel staircases in Spain.

effects, while the Webb nucleus was late in its class of Italianate forms.

Periods and their lengths. Thus every thing is a complex having not only traits, each with a different systematic age, but having also clusters of traits, or aspects, each with its own age, like any other organization of matter, such as a mammal, of which the blood and the nerves are of different biological antiquity, and the eye and the skin are of different systematic ages.

Because duration can be measured by the two standards of absolute age and systematic age, historic time seems to be composed of many envelopes, in addition to being mere flow from future to past through the present. These envelopes, which all have different contours in the sense that they are durations defined by their contents, can be grouped easily by large and small families of shapes. We are not concerned now with the diminutive shapes of personal time, although each of us can observe in his own existence the presence of such patterns, composed of early and late versions of the same action. They extend through all individual experience, from the structure of a few seconds' duration, to the span of the entire life. Our main interest here is in the shapes and forms of those durations which either are longer than single human lives, or which require the time of more than one person as collective durations. The smallest family of such shapes is the annual crop of costume fashions carefully nurtured by the garment industries in modern commercial life, and by court protocol in pre-industrial regimes where fashion was the surest outward mark of high social class. The largest shapes, like metagalaxies, are very few: they dimly suggest their presence as the giant forms of human time: Western civilization; Asiatic culture; prehistoric, barbarian, and primitive society. In between are the conventional periods based upon the solar year and the decimal system. Perhaps the real advantage of the century is that it corresponds to no natural or determinable rhythm of happening whatsoever, unless it be the eschatological mood overtaking people at the approach of a

59721

millenary number,[6] or the *fin de siècle* languors induced after 1890 by mere numerical parallelism with the 1790's of the French Terror.

There is certainly nothing in the history of art corresponding either to a century or to its tenth part. Yet when we consider the conventionally recognized span of Greco-Roman art, we are confronted with ten centuries—one millennium, from c. 600 B.C. to c. A.D. 400, as a possible duration. But no other millenary durations come to mind, and the Greco-Roman one depends upon arbitrary cuts at both beginning and end.

Rather than take space to review the cyclical conceptions of "necessary" historical durations which belong to another kind of speculation, we might consider more closely the periods that are said to correspond to known "working" durations and intervals in the history of things. A year is surely valid—it contains the round of the seasons. Many sorts of work fit into its span. The human frame ages perceptibly in a year, and forward plans in any detail are put forth year by year.

The Roman lustrum of five years has returned to favor in the planning of the socialist states. It is certainly more practicable a span for human affairs than the decade, which is too long for practical plans, and too short for many records. The decade is only a decimal position in the century. Both the decade and the century are arbitrary intervals rather than working durations. Other civilizations preferred a shorter duration, like the 52-year period of the Mexican peoples, composed of four indictions of 13 years each. It corresponds roughly to the length of an adult existence. This correspondence may have been coincidental, as the 52-year cycle was constructed for astrological use by an agricultural people, upon the combination of the solar year with a ritual farmer's year 260 days long.

More to the point than our century is the length of a human generation. It is differently calculated according to different pur-

6. H. Focillon, *L'An mil* (Paris, 1952).

poses and in different periods: in demographic studies it is esti-
mated as 25 years, but in general history it runs to 32–33 years.
The longer duration probably corresponds better to the happen-
ing of general events, while the lesser figure matches the simple
happening of biological replacement. Three generations approach
our century, and it might be thought that such a cycle would be
useful in our studies, corresponding to the revolutions of fashion,
whereby the taste of the grandparents in clothes and furniture,
after having been rejected by the children, returns to favor in
the generation of the grandchildren. In practice, however, these
cyclical returns of fashion require less than half a century, and
they are subject to deforming interferences from other sectors of
happening, as Kroeber and Richardson showed in their remark-
able study based on ladies' fashions since about 1650.[7]

The indiction as module. We have no customary calendrical
duration corresponding either to single life expectancies (the
Biblical "threescore and ten" is the exception) or to the statistical
estimate of the length of a generation (25–33 years). Both of
course have rapidly changed in the past century. Before 1800
life expectancy differed little from the expectancies recently es-
timated for paleolithic man, who at birth like Romans and *ancien
régime* Frenchmen, would be expected by a modern actuary to
enjoy less than 25 years. In their own time, of course, these per-

7. Jane Richardson and A. L. Kroeber, "Three Centuries of Women's Dress
Fashions. A Quantitative Analysis," *Anthropological Records,* 5 (1940), No. 2
(Univ. of California): "the *how* of the unsettlement of dress style is *not* dictated
by the sociopolitical conditions; that must be due to something in the set of the
fashions themselves—something within the structure of fashion . . ." Elsewhere
and later Professor Kroeber, in *Style and Civilizations* (Ithaca, 1957), returned
to the theme of immanence. On the independent appearance of similarities in
corresponding phases of different cultures he wrote (p. 143) that the phenomenon
(e.g. Japanese "impressionism" in the painting of Sesshu, A.D. 1419–1506) is
"immanent in a scheme of development or growth . . . as a toddling gait is a
function of infancy, tumultuousness of adolescence, a stooping body of age."
He concluded, however, that "assumption of immanent forces is best left as a
last recourse. . . . More likely are secondary or pseudo immanences: internal
cultural sets of varied strength which have been gradually developed as a result
of external forces" (p. 159).

sons were afflicted by no such idea: some people lived to be old, and others died young, but no one kept very close records. The working divisions of a human life were therefore much the same as they are today. Infants, children, and adolescents; young, mature, and old adults were the six usual age classes. Of these only the last four concern us, embracing the productive life-span of artists and craftsmen, from about twelve or fifteen years of age upwards. Hence the working lifetime of the man of art may be put at about 60 years, of which probably only 50 are spent at full power. We may take 50–60 years as the usual duration of an artist's life, rather than any figure over 60. Its four periods— preparation, followed by early, middle, and late maturity—each lasting about 15 years, resemble the indictions of the Roman calendar as well as the climacteric periods of developmental psychology. In any case, the term "indiction" is better than the "decade" of conventional usage. The decade is so short that it often fails to match the significant shifts in an artist's life-work. Periods longer than the indiction miss them again: something more than ten and less than twenty years best corresponds both to the vital periods of biography as well as to the critical stages in the history of forms.

Let us turn from artistic biography to the duration of the linked series of events which principally engage us. Certain classes of technical developments in the history of art require about 60 years for their formulation and 60 years for the first systematic applications. The early history of large-scale rib-vaulted construction in Gothic architecture began in the Ile de France about A.D. 1140, and all the components of the Gothic spatial assembly were in existence by 1200. Some students of the question see the first formulation in Anglo-Norman territory, and its critical initial period as enduring from 1080 to 1140. Two distinct stages of inventive elaboration are present; the point here is that each lasts about 60 years. A similar phenomenon is the appearance of Greek vase painting in two stages of about 60 years each, hinged c. 510 B.C. Other examples are the development of the pictorial

system of the Renaissance in central Italy during about sixty years in the fifteenth century, or the appearance of tall steel-frame architecture after 1850 in the United States and Europe. Each of these series had its prodrome of scattered experiments preceding the main campaign.

This suggestion of doubled 60-year durations for certain important sequences in the history of art is an empirical one. No prior idea of "necessary" evolution has governed the observation of length. Small differences of opinion might arise about beginning and ending dates, but no one would contradict the magnitude itself in any one of these instances, especially when it is clear that we are not talking about "styles of art," but only about the history of special forms among related examples occurring in limited regions.

The duration embraces only the generations of the invention and *mise au point,* until the time when the system attained general currency in a much larger region, as a completed entity suitable for indefinite repetition. This time corresponds to what has often been called the "classic" stage: the age of Phidias, the great cathedrals c. 1200 in northern France, or the High Renaissance c. 1500 in Italy.

Non-European examples with similar double-stage durations of 60 years each are known, such as Maya sculpture in the fourth and fifth centuries A.D., or Japanese wood-block prints after 1650. The examples all seem commensurate, involving novel technical, thematic, and expressive resources and providing fresh means of achieving a wide range of structural or descriptive aims. The general validity of the doubled 60-year duration of about 120 years, in two stages of tentative formulation and rapid exploration requires much more verification and many more examples before we can know whether or not it depends upon a specific kind of cultural organization. The pre-Columbian American evidence already strongly suggests such a minimal duration for urban civilization.

A possible test case is offered by paleolithic painting, with

two main regional variants in the Dordogne and the Cantabrian caves which vary in types and expression about as much as French and Spanish painting in the seventeenth century. Our question concerns duration. Although some scholars ascribe thirty or forty centuries of ice-age time to the artistic tradition of these paintings, it is on small evidence, and the possibility still exists that each group of paintings, exemplified at Lascaux and Altamira, was produced by a few generations of painters reprieved from the routine of nomadic existence for a few centuries by some favoring accident of time and place.[8] If that were the case, then our typical minimal duration for the ages of invention might be shown to occur as a temporal category in human effort, independently of cultural mode.

The separation into paired 60-year periods—formulation followed by systematic extension—is drawn mainly from the historical accumulations themselves. A common span connecting history and biography is suggested by the 60-year period, which of course is only an approximation for convenient reference. Sixty years is also the length of the single complete productive life. Very few if any artists, however, remain upon the crest of the wave for so long. Staying power probably depends on "entrance." Otherwise, the individual's powers of invention usually are limited to youthful years. If later in life he achieves new forms, they are likely to be mature realizations of early intimations. The significant phasing of most lives is by portions like the indiction of fifteen years. The full, active life-span embraces about four such indictions. As we study the pulses of those linked series of events—Anglo-French Gothic architecture, Greek pre-

8. The most recent radiocarbon dates from Altamira in Spain and Lascaux in France suggest that the two systems of cave paintings are just possibly contemporary within the span of one quarter-century (Altamira charcoal, Magdalenian III midden deposits, 13,540 B.C. ± 700; Lascaux charcoal from lower fissure of Grotto, 13,566 B.C. ± 900). H. Movius, "Radiocarbon Dates and Upper Palaeolithic Archaeology in Central and Western Europe," Current Anthropology, 1 (1960), 370–72. Of course at the other extreme the dated materials may be 1,600 + years apart.

classic sculpture, or Central Italian painting—all are similar or
linked series of related solutions spreading over about 120 years
in two stages of 60 years, each divided by artistic generations or
indictions of 15 years.[9] The indiction measures many distances
in historical duration. It is a measure drawn from experience,
like paces, feet, and ells, providing us at least provisionally with
a module to connect things with individual lives and the genera-
tions of man.

Even longer durations are now the next units upon which to
base observations of shape. One likely span is near three centuries,
and it is the approximate duration of each principal stage of
several civilizations whose durable manufactures have been re-
covered in some detail.[10] An example is the length of the major

9. This indiction is an empirical observation. It does not derive from any
mystique of generation by birth-year, such as W. Pinder's in *Das Problem der
Generationen* (1928). Its resemblance to the table of generations averaging fifteen
years each from 1490 to 1940 in European letters, as presented by H. Peyre, *Les
Générations littéraires* (Paris, 1948), is fortuitous. M. Peyre observed that occasional
short generations of 10 years occurred when the work demanded: in other words,
that the independent variable is not the generation but the work it has to do,
as in the sense of my argument. M. Peyre, whose remarks here are brief, wrote
as follows (p. 176), "Il y a des époques maigres ou mal définis . . . il y en a au con-
traire où l'on vit plus intensément, et où l'on brûle les émotions, vide les idées,
épuise les hommes avec fièvre." Other French periodizations by fifteen-year in-
tervals occur in the works by J.L.G. Soulavie, *Pièces inédites sur les règnes de Louis
XIV, Louis XV et Louis XVI* (Paris, 1809) and L. Benloew, *Les Lois de l'histoire*
(Paris, 1881), scanning the period 1500–1800 by "évolutions" averaging 15 years
each.

10. In advancing this division, I bear in mind the astringent observations by
R. M. Meyer, "Principien der wissenschaftlichen Periodenbildung," *Euphorion,
8* (1901), 1–42. He shows that periods in history are neither necessary nor self-
evident; that all development is continuous; that periodology is entirely a matter
of convenience dependent mainly upon aesthetic considerations, especially in re-
gard to the proportion and number of periods.

J.H.J. van der Pot, *De periodisering der geschiedenis* (The Hague, 1951), concurs
in stating that "it is impossible to formulate directives for the correct proportion
of the duration of the periods in relation to each other, and for their number."
He urges that periodization, which "forms the quintessence of history," should
be idiographic (i.e. not based on "historical law") and endocultural, arising
from subject-matter rather than from exocultural "necessities of geography,
biology, or the psychical qualities of man."

divisions of the pre-Columbian American civilizations for some
two thousand years prior to the Spanish Conquest. This figure
was at first—early in this century—only a guess based upon
several converging lines of evidence, but it recently has been
confirmed by radiocarbon measurements showing the intervals
between the crises in the archaeological record to be of this order
of magnitude. It measures the duration of artifact stages, such as
the early, middle, and late pottery crafts of the villages of Mexico
or the central Andes under the rule of theocratic states during
the millennium before A.D. 1000.

Closed series were mentioned earlier (p. 35) as an illusory and
artificial conception, since no class ever finally closes, being
always subject to renewed activity when novel conditions re-
quire it. We nevertheless might distinguish now between con-
tinuous and intermittent classes. Continuous classes concern only
the largest groups of things, such as the whole history of art, or
the most common classes, such as household pottery, of which
the manufacture never ceases.

Intermittent classes. Two kinds of intermittent classes immedi-
ately appear: those which lapse inside the same cultural grouping,
and those which span different cultures. Intermittent inside the
same culture are such arts as enameled jewelry, which lapsed
after the Renaissance, excepting for infrequent resumptions such
as the jewelry of the Fabergé family in nineteenth-century Russia,
or the work of John Paul Miller in Cleveland, who has resumed
the gold granulation technique commonly used by Etruscan
goldsmiths. Tempera painting was long disused because of the
ascendancy of oil painting in the fifteenth century, until a variety
of nineteenth- and twentieth-century conditions led to its re-
vival, as in the academy of tempera painting that flourished at
Yale until 1947, based upon the fourteenth-century text by
Cennino Cennini as edited by D. V. Thompson, and taught by
Lewis York, in order to prepare students for the mural-painting
commissions that the public works program of the 1930's had
made possible. True rib-vaulted construction had an astonishing

revival in this century after long disuse, first with Gaudi and in later ferro-concrete studies of ribbed structure.

Such intermittent classes are easily recognized as being composed of impulses so separate that distinct groups of inventions are really present. Yet the new group would be impossible without the tradition and the accomplishments of the earlier group buried deep in its past. The old class conditions its new continuation more pervasively than the living generation usually cares to remember.

The history of transcultural diffusion in turn contains several kinds of motion. Under pre-industrial conditions of travel, great distances as between Imperial Rome and Han-dynasty China were traversed at first only by the most useful inventions. Systematic missionary efforts to transform the entire symbolic structure of Chinese civilization, by Buddhists from India after the sixth century, and by Christians in the sixteenth and seventeenth centuries were temporarily successful, but they could never have been begun without the ample prior tradition of useful learning carried to China by commerce. Occasionally, as in the sixteenth-century Spanish conquest of Mexico and Peru, abrupt military action replaced these motions of commercial and missionary penetration. Conquest was followed at once by massive European substitutions of useful and symbolic behavior for native traditions. Only the useful items new and necessary to Europeans survived the wholesale destruction of the native American civilizations (potatoes, tomatoes, chocolate, etc.).

Very few native art forms have so far survived this wreck.[11] The village art of Mexico has a few muted or commercial recalls of Indian antiquity. The principal figures of twentieth-century

11. The eschatology of civilizations is a subject still undisturbed by deep thought. See W.H.R. Rivers, "The disappearance of useful arts," *Festskrift tillegnad Edvard Westermarck* (Helsingfors, 1912), pp. 109–30; or my essay entitled "On the Colonial Extinction of the Motifs of Pre-Columbian Art," *Essays in Pre-Columbian Art and Archaeology for S. K. Lothrop* (Cambridge, Mass., 1961); and A. L. Kroeber's remarks on "The Question of Cultural Death" in *Configurations of Cultural Growth* (Berkeley, 1944), pp. 818–25.

Mexican painting, Orozco, Rivera, and Siqueiros, all amplified
the Indian past, and certain foreigners enlarged many native
themes in their own terms. Frank Lloyd Wright renewed an
experimentation with Maya corbel-vaulted compositions that
had lapsed since the fifteenth century in Yucatan, and he resumed
it with the technical resources of his time at the point where the
Toltec-Maya builders of Chichen Itza desisted (Barnsdall House,
Los Angeles, 1920). Henry Moore, the modern British sculptor,
likewise returned to variations upon the theme of angular re-
cumbent figures, based upon a Toltec-Maya tradition of about
the twelfth century. John Flanagan, the American, produced
compact animal studies in an idiom with fifteenth-century Aztec
antecedents. These twentieth-century continuations of the un-
finished classes of fifteenth-century American Indian art can be
interpreted as an inverted colonial action by stone-age people
upon modern industrial nations at a great chronological distance.
Through its formal vocabulary alone, the sensibility of an extinct
civilization survives in works of art to shape the work of living
artists in a totally unrelated civilization half a millennium later.

The phenomenon is of course possible at every level of his-
torical relationship. It transformed Western civilization most pro-
foundly in the Renaissance, when the unfinished work of Greco-
Roman antiquity took possession of the entire collective mind of
Europe to dominate it until deep into the twentieth century,
even as late as Picasso's illustrations of Ovid's *Metamorphoses*.
Today classical antiquity has been displaced by even more re-
mote models, from the prehistoric and primitive art of all parts
of the world, in a similar mortmain action as if to round out the
principal contours of long-unrealized possibilities. In other words,
when people create new forms, they commit posterity at some
remote interval to continue in the track by an involuntary act
of command, mediated by works of art and only by them.

Here is without doubt one of the most significant of all the
mechanisms of cultural continuity, when the visible work of an
extinct generation still can issue such powerful stimuli. Whether

the ancient messages thus continue indefinitely to echo down the corridors of time is unclear when the record still is so short. There nevertheless has been only one brief moment when a people have consciously sought total independence from past formulas of expression. This moment lasted for a generation after 1920 in Europe with the label of functionalism. Historical parallels are perhaps to be sought in various iconoclastic movements of religious reform, as in Constantinople, in fifteenth-century Florence, in Islam, in Jewry, and in Puritan Protestantism. Under the functional program all possible products were designed anew in search of forms corresponding solely to uses, under the doctrinal belief that the necessary alone is beautiful.

Arrested classes. As we approach incomplete classes, we should briefly explore the related theme of the abandoned, arrested, or "starved" classes, which have been left unexploited. Examples are fairly common in the lives of unrecognized inventors whose discoveries remained obscure for many years until a lucky chance brought their work to the notice of persons competent to continue it. Notorious examples occur in the history of science: the fundamental genetic studies of Gregor Mendel, which went unattended for nearly forty years, are a celebrated instance. The history of art has many parallels, such as Claude Ledoux, whose neo-classic use of the forms of pure geometry under Napoleon prefigured the hard abstractions of the "International Style" in the twentieth century; or Sir Joseph Paxton, whose prefabrication of metal parts allowed him to design the prophetic spaces of glass and steel in the Crystal Palace of London in 1850–51. Precursors like these have the power to produce the solutions to a general need long before the majority experiences the need itself. Indeed, the way in which the need is framed often owes its final form to these premature talents.

After neglect, conquest is the other great occasion for incomplete classes, when the victor overthrows native institutions and replaces them with extensions of his own. If the victor has alluring benefits to offer, like Alexander or Cortés, he makes the

continuation of many traditions both unnecessary and impossible. The *locus classicus* for incompletion is the case of sixteenth-century America, when native initiative quickly ceased under the blows of the Conquest and the attraction of superior European knowledge.

At the same time the creation of a colonial Spanish civilization in America can be taken as the classic case of extended classes. These occur when inventions and discoveries made in the parent society are passed on to the colony together with the persons— mechanics and artisans—needed to get up the corresponding crafts. Latin America before 1800 is an impressive example of Hispanic extension, although innumerable other cases of smaller territorial and demographic size illustrate the point quite as well, like the imposition of Islam upon Christian Visigothic Spain, or the Hellenization of India by Alexander's armies.

It is in the nature of events that incomplete classes are likely to be less well documented than extended classes: conquerors and colonial agents usually keep poor records of the ways of the people whose traditions they seek to extinguish. Christian ethical behavior in the Spanish colonization of America nevertheless produced encyclopedists of native culture like Bishop Diego de Landa for Yucatan, Friar Bernardino de Sahagún for Mexico, and Father Bernabé Cobo for the Central Andes, to whom we owe unusually full records of native behavior prior to the sixteenth century. Above all in the things made by Mexican Indian craftsmen, the abrupt replacement of one visual language by another is clearly apparent within the span of a single generation pivoting upon the mid-sixteenth century.

In highland Mexico the peninsular Plateresque art of 1525–50 displaced Aztec art. The systematic ages of these two visual languages particularly interest us here. Spanish Plateresque forms at that time were in the later half of their history. The early expressive character of abrupt, uncontrolled dissonant energy that marks early Plateresque work had yielded in Spain by 1540 to the later more modulated manner of proportioned harmonies

learned from the Italian theorists of the preceding century. What came to Mexico was therefore systematically old, whether it was a retarded late medieval ornament, an out-of-date Italian idiom, or an up-to-date Plateresque decoration.

On the Indian side, Aztec sculpture displays an exceptional command of symbolic indications of death and vitality, but it was a new art, formed from the resources of many subject peoples, perhaps utilizing a tribal tradition of vigorous expressiveness, and probably not antedating the reign of Ahuitzol late in the fifteenth century, less than a generation before the arrival of the Spaniards. The identity of these gifted sculptors will never be known. Yet we can be certain that it was a systematically new art which yielded to an older art brought from Spain. The difference of systematic age was not great, but the differences of technical equipment and antecedent tradition were enormous.

The value of the situation to us is that we know beyond doubt of the incompleteness of the native series: it was cut off before its time. It never had any later occasion to find its natural conclusion. It gives us the clinical example of the incomplete cultural series cut off by an extended one.

The displacement of new classes by older ones shows the discontinuity, as when native laborers had to regress in European terms, in order to master the new techniques. Thus they learned vaulted construction by building the simpler types like early twelfth-century vaults in Anglo-Norman territory, or they carved simple chip-cut ornament with steel instead of stone tools, before trying more intricate modeling. The process is one of recapitulation. New participants review the whole class in a contracted form in order to learn the present position. It recurs in every school and academy, when the previous habits of the pupil are displaced by new routine, taught in sequence from fundamental motions to final operations. Every moment of routine learning contains this discontinuity between the two types of past knowledge, that of the learner who does it the first time and that of the teacher, who does it for the nth time.

In this sense of routine learning, all pre-professional education and all colonial situations belong to the replica-mass (p. 39) rather than to the form-class where innovations are discovered and explored. Hence colonial societies more often than not resemble learners with inadequate prior training to whom the new experiences are insurmountably difficult, and who fall back upon a convenient minimum of working knowledge. In this way a characteristic arrested development of active form-classes may occur in provincial and rustic environments. Rustic arts are the principal elements of colonial artistic life. Usually one stage of development is separated from a metropolitan series in a remote and isolated setting, where the original impulse is repeated again and again with diminished content but enriched accessories. Examples are the peasant costumes of nineteenth-century Europe, where arrested moments of *ancien régime* court fashions, some of them several hundred years old, flourished by repetition in the rural countryside.

It is not easy to define a colonial society to everyone's satisfaction. In this context, however, it can be regarded as a society in which no major discoveries or inventions occur, where the principal initiative comes from outside rather than from within the society, until it either secedes from the parent-state or revolts. Many politically independent self-governing societies nevertheless remain colonial in our sense for long periods after independence because of continuing economic limitations that restrict inventive freedom. Thus colonial states created by conquest all display incomplete series in differing grades of dilapidation.

Extended series. Colonial states also display many kinds of extended series which manifest the dependence of the colony upon the mother state. These extensions are staffed by persons schooled in the parent country: the classic example as usual is colonial Latin America, where the higher officials of the regional governments all were of Peninsular origin, with native-born officials (Creoles) admitted only to the lower ranks. Peninsular architects, sculptors, and painters very early implanted among native crafts-

men those European traditions of design and representation from
which the colonies never lapsed even when revolting from
Spanish political rule.

The consequences of the colonial extensions from the mother
country are easily charted in Latin America. Equipping a conti-
nent with cities, churches, houses, furnishings, and tools required
a gigantic outlay of energy at minimum standards of perform-
ance. The native labor learned a behavior at the outset which has
been perpetuated ever since by small human numbers, by the
unfavorable dispersal of habitable zones, by the immense dis-
tances between towns, and by the imperfect communications
among colonies as well as between the colonies and the Peninsula.

The sluggish and careless pace of colonial events was overcome
only thrice in three centuries, and only in architecture: the build-
ings of Cuzco and Lima from 1650 to 1710; Mexican viceregal
architecture from 1730 to 1790; and the Brazilian Third Order
chapels of Minas Gerais from 1760 to 1820. Of course Latin
America has towns and villages of extraordinary beauty, like
Antigua in Guatemala, Taxco in Mexico, and Arequipa in Peru,
but their charm, favored by climate and setting, rests upon the
relaxation of more rigorous standards of invention rather than
upon the eager quest for excellent newness that made Florence
or Paris for so long the centers of many epochal changes in the
history of things. In Antigua or Arequipa or Ouro Preto, as at
picturesque towns in every province of Europe, beauty was at-
tained by concord in simple old themes, much reduced from the
difficult *pièces de maîtrise* we see in great cities and at court. It is
the beauty of oft-repeated traditional forms favored by nature,
rather than the beauty of things separated from the immediate
past in their makers' intense quest for new forms.

The effects of such provincial extensions upon the arts of the
mother country are on the whole beneficial. The opportunities
available to builders, painters, and sculptors in the Spanish
colonies swelled their numbers at home. Thus Seville, the chief
port for transatlantic shipping, was the focus of the golden age

of Spanish painting in the seventeenth century rather than the new court at Madrid, which often drew its great talents from the Sevillian school. The florescence of Greek architecture in the fifth century likewise depended in part upon favoring conditions in the prior expansion of the Greek cities to colonies in the western Mediterranean. Roman imperial architecture benefited from colonial extensions in much the same way, with a gigantic increase in the overall building requirements of the state, which stimulated a swift increase both in numbers and in professional quality among homeland architectural designers. These correlations cannot possibly be proven directly, and they are suggested only by parallels with more recent situations. If tenable, they belong among the few occasions when the economic situation and the artistic activities of a people appear to interlock closely.

Economic historians have discussed the idea that artistic florescence and economic disorders are correlated.[12] Certainly the Spanish example of a relationship between artistic excellence and the abundance of artistic opportunities also fits such a correlation between artistic excellence and material crisis, for the seventeenth century in Spain was an epoch of staggering economic difficulties above which painting, poetry, and the theater flowered imperishably. But to keep aesthetic events together in the same perspective, let us say that colonial or provincial stagnation is the reciprocal of metropolitan vivacity, that one is secured at the cost of the other in the same regional entity. Then every focus or center of invention requires a broad provincial base both to support and to consume the productions of the center. Hence for every extended class, like thirteenth-century Gothic art in the Mediterranean basin, we find a world of replicas in Naples or on Cyprus, differing mainly in regional accent, but all pointing to a common center of origin as copies of inventions made among the new cities of northwestern Europe, in southern England, or northern France less than a century earlier.

12. Robert Lopez, "Hard Times and the Investment in Culture," *The Renaissance: A Symposium* (New York, 1952).

Wandering series. Not to be confused with such replicating extensions to province and colony are certain classes whose continued development appears to require periodic changes of setting. The examples of this phenomenon of wandering series are best taken among extremely large classes, such as Romanesque-Gothic-late medieval architecture, or Renaissance-Mannerist-Baroque painting in Europe, where remarkably uniform displacements of the focus of invention may be noted. They occur at intervals of about ninety years when the entire geographical grouping of the centers of innovation shifts to different bases.

Symptomatic of the principal changes are the well-known displacements from abbey to cathedral to city in medieval architecture. Another is the migration of the centers for important painters from the little Central Italian city-states to the sixteenth-century courts and the prosperous seventeenth-century commercial centers.

One explanation, which reduces art to a phase of economic history, is that artists follow the true centers of power and wealth. It is an incomplete explanation, for there are many centers of wealth and power, but there are few centers of major artistic innovation. Artists often gravitate to the lesser centers of wealth and power, like Toledo, Bologna, and Nürnberg.

Despite the inventor's solitary appearance he needs company; he requires the stimulus of other minds engaged upon the same questions. Certain cities early accepted the presence of artists' guilds, thereby establishing precedent and ambience for their continuing presence. In other cities a puritanical or iconoclastic tradition long proscribed the arts of the age as useless or frivolous. Certain cities show the touch of important artists at every turn: Toledo and Amsterdam still bear signs of the presence of their great seventeenth-century painters; Bruges molded and was molded by many generations of painters; and the greatest architects have shaped the urban presence of Florence and Rome. The artist requires more than patronage; he also needs association with the work of others both dead and alive engaged on the same

problems. Guilds, côteries, botteghe, and ateliers are an essential
social dimension of the endless phenomenon of artistic renewal,
and they cluster by preference in permissive environments
having both craft traditions and proximity to power or wealth.
Hence the slow movement of the centers of innovation from one
region to another cannot adequately be explained by economic
attraction alone, and it is justified to search for other motives.

Possibly more important than wealth in accounting for wan-
dering series is the question of saturation. An old solution often
satisfies its need better than a more recent one. As noted earlier,
each class of forms both shapes and satisfies a need which con-
tinues throughout several stages of change in the forms. The need
changes less than the different solutions devised for it. The history
of furniture has many examples of this relationship between fixed
need and varying solution. Today many furniture forms of
eighteenth- and nineteenth-century date still fulfill perfectly the
need for which they were designed, and often far better than the
machine-made chairs and tables of modern design. When the
industrial designer discovers a new shape to satisfy an old need,
his difficulty is to find enough buyers for the new shape among
people who already own satisfactory old forms. Thus every suc-
cessful manufacture tends to saturate the region in which it is
made, by using all the occasions that might require the thing.

To take another example: after 1140 for about a century the
use of columnar statues of Biblical figures in the embrasures
flanking church doorways became common, as the royal portal
formula which eventually radiated from the Ile de France around
Paris throughout Europe. In France north of the Loire, the prin-
cipal stages of its elaboration can still be retraced in the great ca-
thedral doorways. In that region, however, the success of the
royal portal formula prevented the successful emergence of any
other solution. Instead, the theme of grouped statues in the em-
brasures became more and more stereotyped with the spread of
French Gothic art. In other words, every durable and successful
form saturates the region of its origin, making it impossible for

newer linked forms to occupy the same positions. Around every successful form, furthermore, there arises a protective system of sorts for its maintenance and perpetuation, so that the opportunities for replacement by new design are further reduced in places where older things fill the same need. A living artist often may encounter harder competition from the work of artists dead for fifty years than from his own contemporaries.

A region with many unfulfilled needs, having the wealth to satisfy them, will under certain conditions attract innovations. Chicago after 1876 was doubly attractive to architects, both as the established metropolitan center of a new economic region, and as a city which the great fire had left in ashes. The florescence of the "Chicago School," with men like Burnham, Sullivan, and Wright later on, was the consequence. But the rebuilding of Chicago after 1876 would have been a provincial extension rather than an epochal renewal of American architecture, without a favorable juncture in the history of forms. Such a favorable juncture consists in general of unused technical and expressive opportunities allowing the institution of new form-classes across a broad band of needs. With the ageing of the entire spectrum of form-classes, as in the later centuries of each great epoch of civilization, most urban environments have been saturated many times over by the work of earlier stages. Thus one dominant characteristic of such late periods near the end of each major division of history, like the eighteenth century in western Europe, is the ascendancy of fashionable manners of decoration such as Rococo, which are adapted to the superficial cosmetic remodeling of still serviceable older structures inside and out.

Simultaneous series. The wide range of systematic ages among different classes at the same moment always makes our own present seem like a complicated and confusing mosaic, which resolves into clear, simple shapes only long after it has receded into the historical past. Our ideas about Middle Minoan time are clearer than our ideas about Europe between the World Wars, partly because less is known, partly because the ancient world

was less complex, and partly because old history comes into long perspective more easily than the close view of recent happening.

The older the events are, the more are we likely to disregard differences of systematic age. The Parthenon is a retarded example of the peripteral temple. This class was already very old when Ictinos was born. The fact of systematic age, however, is rarely if ever mentioned in classical studies. Classical scholars have to rely upon approximate dates for large groups of things, and within series of things they rarely can fix dates exact to the year. The idea is more developed in studies of Gothic medieval sculpture, as when E. Panofsky sought to distinguish the hands of old and young masters at Reims Cathedral in the same decade of the thirteenth century. In the connoisseurship of Renaissance painting, apparent inconsistencies of dating and authorship have often been resolved with an implicit invocation of systematic age, by saying that the master persisted in the use of an old-fashioned idiom long after his contemporaries had abandoned it. In studies of contemporary art, finally, there are no problems of dating, but the need to sort the schools, traditions, and innovations implies the idea of systematic age.

Different configurations vary this fundamental structure of the present without ever obscuring it completely. One of the uses of history is that the past contains much clearer lessons than the present. Often the present situation is merely a complicated instance of conditions for which an ideally clear example can be found in the remote past.

Athenian vase painting in the closing decades of the sixth century B.C. offers a lucid instance of simultaneous form-classes at a small scale and under completely intelligible conditions. The black-figured style of bodies silhouetted like black paper cutouts upon light grounds had prevailed for some generations, and it allowed an entire series of advances in the technique of representation, favoring always the decorative integration of figure and ground by harmonious and interesting void shapes. But this manner limited the painter's expressive resources. The solid dark

figure prevented him from describing gestures or expressions, and it drew the eye to and beyond the figural contour rather than into the content of any linear enclosure.

About 520–500 B.C., black-figure style had reached that stage in the exploration of these graphic possibilities which we have here designated as "late." At the same time a radical technical change was introduced that allowed a new form-class to take shape. The relation of figure and ground was inverted by the simple device of letting the linear enclosures have the color of the pottery ground, while the surrounding areas were painted black. This new red-figure style allowed painters to describe gesture and expression by more copious linear means than before, but it destroyed the old harmonious relation of figure and ground, conferring upon the figure a prepotence that robbed the ground of its former decorative significance. The innovation permitted the opening of a new series: early and late examples of red-figure style follow in order after the disappearance of late black-figure technique.

About eighty or ninety Athenian vessels are preserved on which scenes are painted in both styles, and some of these represent the same scene, such as Heracles and the bull, by the Andokides painter, on opposite sides of the same vessel, in black-figure and red-figure techniques, as if to contrast the possibilities of the old and the new styles. These dimorphic vases (or "bilingual" vases as Beazley called them) are unique ancient documents of the coexistence of different formal systems for an individual painter. They show with great clarity the nature of the artistic decision at any and every moment of history, in the perpetual crisis between custom and innovation, between exhausted formula and fresh novelty, between two overlapping classes of forms.

A group of students upon my suggestion once arranged random selections of black-figure and red-figure vase paintings in order by early and late formal traits. They worked separately under instruction to disregard all other traits such as technique and vessel-shape. The outcome of each list was a pairing of early

black-figure with early red-figure, and late with late, associating things of similar systematic age rather than by absolute chronological date.

Another kind of simultaneity comes from a tomb of the third century A.D. at Kaminaljuyu in the Guatemalan highland. In this tomb A. V. Kidder found many stuccoed tripod vessels, all of the same shape, and of a variant most familiar from Teotihuacán in the Valley of Mexico, a thousand miles away. These vessels were painted in clear unfired earth colors of two styles: early classic Maya and Teotihuacán II, which differ from one another about as widely as Byzantine and Irish manuscript illumination in the ninth century. Kaminaljuyu was a colonial outpost of Teotihuacán on the edge of lowland Maya civilization. Maya pottery traditions were less advanced than in Mexico at that moment, although the Maya were in other respects the possessors of a learning much more complicated than that of their Mexican contemporaries, especially in written astrological and astronomical lore. The potters of Kaminaljuyu, who probably furnished painted vessels in commercial quantities to Maya buyers, simultaneously worked in both styles, that of their homeland and that of their clients.

In brief, the more completely we know the chronology of events, the more obvious it becomes that simultaneous events have different systematic ages. A corollary is that the present always contains several tendencies competing everywhere for each valuable objective. The present was never uniformly textured, however much its archaeological record may appear to have been homogeneous. This sense of the present which we live each day, as a conflict between the representatives of ideas having different systematic ages and all competing for possession of the future, can be grafted upon the most inexpressive archaeological record. Every sherd mutely testifies to the presence of the same conflicts. Each material remnant is like a reminder of the lost causes whose only record is the successful outcome among simultaneous sequences.

The topography of simultaneous classes can be presented in two groups, guided and self-determining. The guided sequences depend explicitly upon models taken from the past: thus revivals, renaissances, and all other model- or tradition-bound forms of behavior are guided sequences.

Self-determining sequences are much rarer, and they are harder to detect. Early Christian art was a deliberate rejection of pagan traditions. The survivals of pagan antiquity were either strategic or unconscious in early Christianity. The Christian sequence, however, rapidly became model-bound, as when the close array of these revivals of Early Christian architectural types finally constituted the Early Christian tradition.[13]

These terms—guided and self-determining sequences—are more than mere synonyms of tradition and revolt. Tradition and revolt suggest cyclical sequence: revolt is linked to tradition in a circular motion, with revolt becoming tradition, which breaks again into revolting fractions and so on *da capo*. Our terms were chosen to avoid this suggestion of necessary cyclical recurrence.

It follows that self-determining motions are necessarily brief, and that guided motions usually become the substance of history. In general, self-determining classes cease either when they turn into classes guided by their own past victories, like Early Christian art or when they lose the field of actuality to some other series. Any present moment therefore consists principally of guided series, each contested by self-determining motions of dissidence. These gradually subside as their substance is kneaded into previous tradition, or as they themselves become new traditional guides to behavior.

Lenses vs. fibers of duration. Here is a possible resolution to the question asked by the proponents of *Strukturforschung* (p. 27). We do not need to assume with them that the parts of culture

13. R. Krautheimer, "The Carolingian Revival of Early Christian Architecture," *Art Bulletin, 24* (1942), 1–38. Erwin Panofsky, *Renaissance and Renascences* (Stockholm, 1960) has charted the later moments in the guided revival sequence which gradually came to displace the self-determining sequence of Early Christian art.

are all either central or radial. They seem to think of a culture as if it were a circular lens, varying in thickness according to the antiquity of the pattern. Instead, we can imagine the flow of time as assuming the shapes of fibrous bundles (p. 37), with each fiber corresponding to a need upon a particular theater of action, and the lengths of the fibers varying as to the duration of each need and the solution to its problems. The cultural bundles therefore consist of variegated fibrous lengths of happening, mostly long, and many brief. They are juxtaposed largely by chance, and rarely by conscious forethought or rigorous planning.

 Conclusion

The historical study of art on systematic principles is about two thousand years old if we include Vitruvius and Pliny. This accumulated knowledge now far surpasses the ability of any individual to encompass its detail. It is unlikely that many major artists remain to be discovered. Each generation of course continues to revaluate those portions of the past which bear upon present concerns, but the process does not uncover towering new figures in the familiar categories so much as it reveals unfamiliar types of artistic effort, each with its own new biographical roster. The discovery of hitherto unknown painters of the stature of Rembrandt or Goya is far less likely than our suddenly becoming aware of the excellence of many craftsmen whose work has only lately come to be accepted as art. For example, the recent advent of Western action painting has prompted the revaluation of a similar tradition in Chinese painting since the ninth century—a tradition to which the West was insensitive until recent years.

FINITE INVENTION

Radical artistic innovations may perhaps not continue to appear with the frequency we have come to expect in the past century. It is possibly true that the potentialities of form and meaning in human society have all been sketched out at one time and place or another, in more or less complete projections. We and our descendants may choose to resume such ancient incomplete kinds of form whenever we need them.

As it is, our perception of things is a circuit unable to admit a

great variety of new sensations all at once. Human perception is best suited to slow modifications of routine behavior. Hence invention has always had to halt at the gate of perception where the narrowing of the way allows much less to pass than the importance of the messages or the need of the recipients would justify. How can we increase the inbound traffic at the gate?

The purist reduction of knowledge. One old answer is to reduce the magnitude of the inbound messages by amplifying what we are willing to discard. This answer was again attempted in Europe and America by the generation between the wars from 1920 to 1940: it required the rejection of history. The hope was to diminish the traffic by restricting it only to pure and simple forms of experience.

Purists exist by rejecting history and by returning to the imagined primary forms of matter, feeling, and thought. They belong to a family spread throughout history. The Cistercian architects of the high middle ages are among its members, as well as the New England craftsmen of the seventeenth century and the pioneers of functionalism in our century. Among these last, men like Walter Gropius took on the old burden of their purist predecessors. They sought to invent everything they touched all over again in austere forms which seem to owe nothing to past traditions. This task is always an insurmountable one, and its realization for all society is frustrated by the nature of duration in the operation of the rule of series. By rejecting history, the purist denies the fullness of things. While restricting the traffic at the gates of perception, he denies the reality of duration.

Widening the gate. Another strategy has been more normal. It requires the widening of the gate until more messages can enter. The gate is bounded by our means of perception, and these, as we have seen throughout the history of art, can be enlarged repeatedly by the successive modes of sensing which artists devise for us. Still another strategy is to codify incoming messages so that redundancies are eliminated and a larger useful volume of

traffic flows. Whenever we group things by their style or class, we reduce redundancy, but it is at the cost of expression.

In these ways the history of art is like a vast mining enterprise, with innumerable shafts, most of them closed down long ago. Each artist works on in the dark, guided only by the tunnels and shafts of earlier work, following the vein and hoping for a bonanza, and fearing that the lode may play out tomorrow. The scene also is heaped with the tailings of exhausted mines: other prospectors are sorting them to salvage the traces of rare elements once thrown away but valued today more than gold. Here and there new enterprises begin, but the terrain is so varied that old knowledge has been of little use in the extraction of these altogether new earths which may prove worthless.

Upon this scene investigators have proceeded as if the life histories of all the principal workers were not only indispensable but adequate and sufficient. Biographical summation does not yield an accurate description of the mother-lode, nor will it account for the origins and the distribution of this immense resource. The biographies of artists tell us only how and why the vein was exploited in such a peculiar way, but not what the vein is or how it came to be there.

Perhaps all the fundamental technical, formal, and expressive combinations have already been marked out at one time or another, permitting a total diagram of the natural resources of art, like the models called color-solids which show all possible colors. Some portions of the diagram are more completely known than others, and some places in it still are sketchy, or they are known only by deduction. Examples are René Huyghe's *Dialogue avec le visible* (1955), an effort to chart the theoretical limits of painting, and Paul Frankl's *System der Kunstwissenschaft* (1938), which seeks to define the boundaries of all art.

The finite world. Were this hypothesis to be verified, it would radically affect our conception of the history of art. Instead of our occupying an expanding universe of forms, which is the contemporary artist's happy but premature assumption, we would

be seen to inhabit a finite world of limited possibilities, still largely unexplored, yet still open to adventure and discovery, like the polar wastes long before their human settlement.

Should the ratio between discovered positions and undiscovered ones in human affairs greatly favor the former, then the relation of the future to the past would alter radically. Instead of regarding the past as a microscopic annex to a future of astronomical magnitudes, we would have to envisage a future with limited room for changes, and these of types to which the past already yields the key. The history of things would then assume an importance now assigned only to the strategy of profitable inventions.

The Equivalence of Form and Expression

When we scan things for traces of the shape of the past, everything about them deserves our attention. Yet this conclusion, which is self-evident once we recognize that things alone allow us to know the past, is generally ignored under the demands of specialized study. Archaeological studies and the history of science are concerned with things only as technical products, while art history has been reduced to a discussion of the meanings of things without much attention to their technical and formal organization. The task of the present generation is to construct a history of things that will do justice both to meaning and being, both to the plan and to the fullness of existence, both to the scheme and to the thing. This purpose raises the familiar existential dilemma between meaning and being. We are discovering little by little all over again that what a thing means is not more important than what it is; that expression and form are equivalent challenges to the historian; and that to neglect either meaning or being, either essence or existence, deforms our comprehension of both.

As we examine the procedures used in the study of meaning and in the study of form, their increasing precision and scope are

remarkable. But the grand catalogue of persons and works is near that state of completion that is heralded by diminishing returns. The techniques of exact dating and attribution, which are methods of measuring the extent and authenticity of bodies of work, change little from generation to generation. Only the historical study of meaning (iconology) and the conceptions of morphology are new in our century.

Iconological diminutions. The learned and subtle iconologists who trace out the convolutions of a humanistic theme through thousands of years have charmed all with the discovery that each period endowed the theme with its characteristic enrichments, reductions, or transformations. As such studies accumulate they are like the chapters of a book by many authors, each treating an element of humanistic tradition, all treating the survival of antiquity. Continuity rather than rupture is the criterion of value among students of meaning.

In iconology the word takes precedence over the image. The image unexplained by any text is more intractable to the iconologist than texts are without images. Iconology today resembles an index of literary themes arranged by titles of pictures. It is not usually realized that iconological analysis depends upon discovering and expanding chosen texts with visual aids. The method is most successful when orphaned images can be reunited with the texts to which they were originally more or less direct illustrations. In the absence of literature, as among the pre-literate Mochica or Nazca peoples of ancient America, there is nothing in writing with which to enlarge our knowledge of the images. We are obliged to overlook conventional meaning. There is no coeval verbal plane to which the image can be reduced or transformed.

When he has texts, however, the iconologist strips the fullness of things down to those schemes that the textual apparatus will allow. Frequent repetition and variation measure the importance of a theme, especially if it has survived the barrier of the Middle Ages. The examples and illustrations spill forth into a few verbal

molds suggested by the texts, and their substance is correspondingly diminished until only meanings survive from the plenitude of things themselves.

On the other hand, studies of morphology, based upon the types of formal organization and their perception, now are unfashionable and they are dismissed as mere formalism by the diligent detectives of texts and meanings. Yet the same sorts of schematic deformation limit both iconographers and morphologists. If the former reduces things to skeletal meanings, the latter submerges them in streams of abstract terms and conceptions which mean less and less the more they are used.

The deficiencies of style. To choose one example among many, the phrase "Baroque style," arising from the study of seventeenth-century Roman works of art, now extends in general use to all European art, literature, and music between 1600 and 1800. The term itself is in no way descriptive of form or period: it was originally *baroco,* a thirteenth-century mnemonic term describing the fourth mode of the second syllogism coined for the use of students of logic by Petrus Hispanus, who later became Pope John XXI.[1] In effect, to speak of Baroque art keeps us from noting either the divergent examples or the rival systems of formal order in the seventeenth century. We have become reluctant to consider the alternatives to Baroque art in most regions, or to treat the many gradations between metropolitan and provincial expressions of the same forms. Nor do we like to think of several coeval styles at the same place. Actually, the Baroque architecture of Rome and its scattered derivatives throughout Europe and America is an architecture of curved planes approaching a system of undulant membranes. These mark the changing pressures of inner and outer environments. But elsewhere in Europe, especially in Spain, France, and the northern countries, another mode of composition prevails. It may be called planiform, or non-undulant, having only ascending

1. Petrus Hispanus, *Summulae logicales,* ed. I. M. Bochenski (Rome, 1947).

crises of accent and stress. Thus the seventeenth-century archi-
tects align either with a planiform tradition or a curviplanar one,
and it is confusing to call them both Baroque.

Indeed names of styles entered general use only after being in-
flated by misuse and incomprehension. In 1908 Otto Schubert
had already extended the Italian term to Spanish forms, when he
wrote *Geschichte des Barock in Spanien*. Here the "historic styles"
now compel more belief than the things themselves. "Spanish
Baroque" has become a more compelling verbalism than the
easily verified reality that Italian and Spanish architecture 1600–
1700 had very few persons or traits in common. The direct
study of Spanish art impedes this sort of generalization: for in-
stance, it is difficult to see a close relation between the archi-
tectures of Valencia and Santiago de Compostela at any time
between 1600 and 1800 for the two cities were not in touch, and
while Valencia's connections were with Naples, Liguria, and the
Rhône Valley, Galicia was related to Portugal and the Low
Countries.

The plural present. Everything varies both with time and by
place, and we cannot fix anywhere upon an invariant quality
such as the idea of style supposes, even when we separate things
from their settings. But when duration and setting are retained
in view, we have shifting relations, passing moments, and chang-
ing places in historic life. Any imaginary dimensions or continui-
ties like style fade from view as we look for them.

Style is like a rainbow. It is a phenomenon of perception
governed by the coincidence of certain physical conditions. We
can see it only briefly while we pause between the sun and the
rain, and it vanishes when we go to the place where we thought
we saw it. Whenever we think we can grasp it, as in the work
of an individual painter, it dissolves into the farther perspectives
of the work of that painter's predecessors or his followers, and
it multiplies even in the painter's single works, so that any one
picture becomes a profusion of latent and fossil matter when we
see the work of his youth and his old age, of his teachers and his

pupils. Which is now valid: the isolated work in its total physical presence, or the chain of works marking the known range of its position? Style pertains to the consideration of static groups of entities. It vanishes once these entities are restored to the flow of time.

Not biography nor the idea of style nor again the analysis of meaning confronts the whole issue now raised by the historical study of things. Our principal objective has been to suggest other ways of aligning the main events. In place of the idea of style, which embraces too many associations, these pages have outlined the idea of a linked succession of prime works with replications, all being distributed in time as recognizably early and late versions of the same kind of action.

Index

WESTMAR COLLEGE LIBRARY

Date Dr